INSPIRING WALT DISNEY

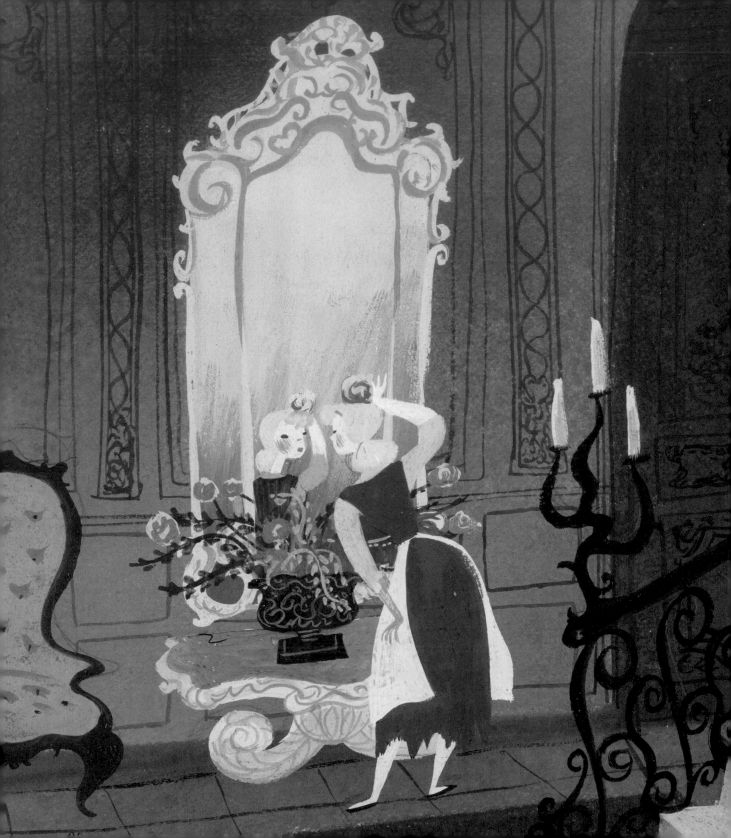

Inspiring Walt Disney

THE ANIMATION OF FRENCH DECORATIVE ARTS

AT THE WALLACE COLLECTION

Helen Jacobsen

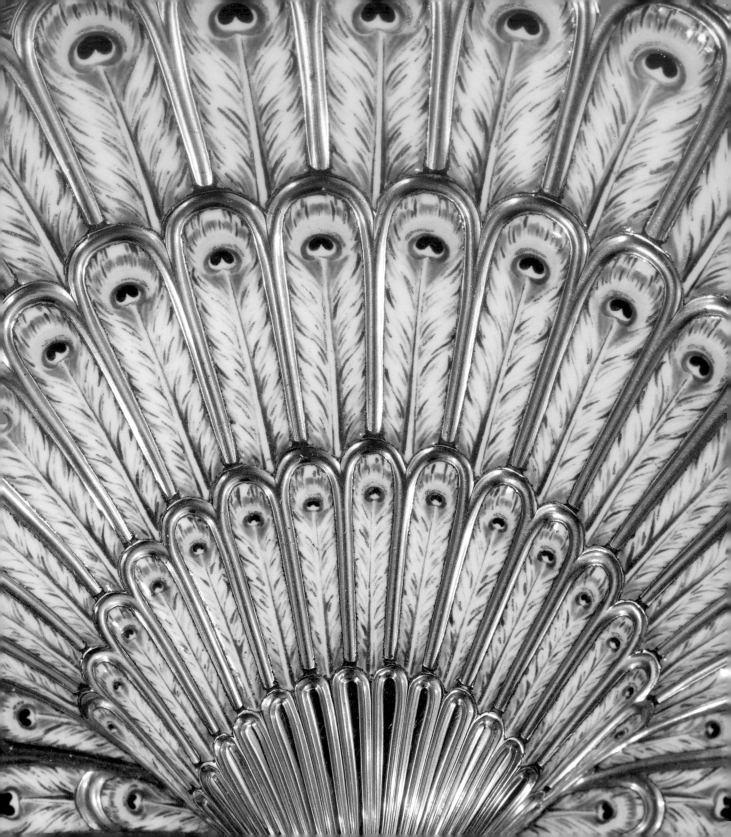

Contents

VII

DIRECTOR'S FOREWORD
DR XAVIER BRAY

I

INSPIRING WALT DISNEY
HELEN JACOBSEN

19

SELECTED WORKS
HELEN JACOBSEN WITH WOLF BURCHARD

The Discovery of Europe 20

Early Animation 26

Cinderella 32

Architecture of the Imagination 42

The Swing 54

Eighteenth-Century Dress 60

Animating the Inanimate 66

98
FURTHER READING

99
PICTURE CREDITS

100
INDEX

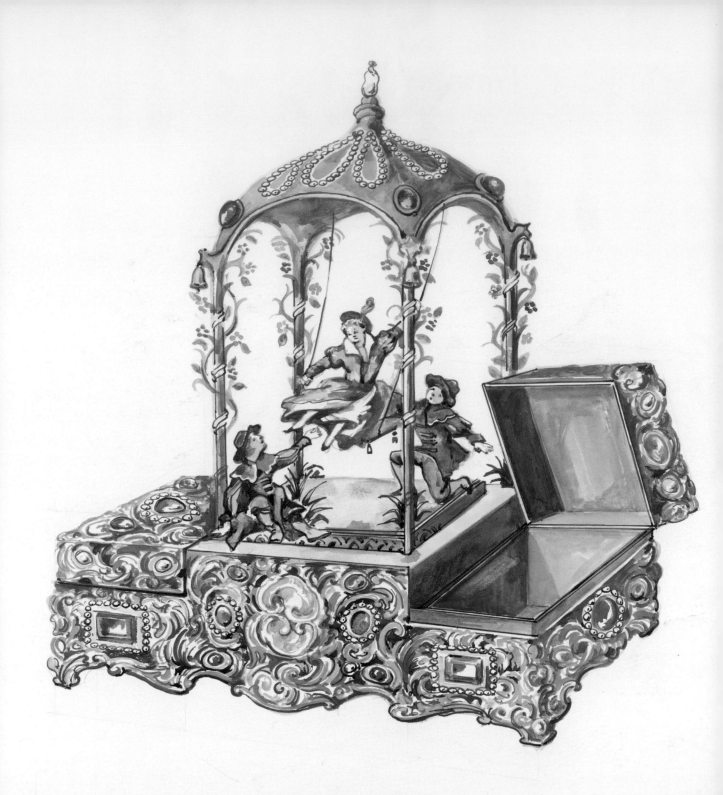

Director's Foreword

SINCE OPENING ITS DOORS in June 1900, the Wallace Collection has frequently been described as a treasure house where one can magically be transported to the world of eighteenth-century France, and enjoy a sense of what it would have been like to live amongst such beautifully crafted objects and within its opulent interiors. The ticking and chiming of the clocks, the gilt-bronze candlesticks, the sparkling chandeliers, and the paintings by Watteau and Fragonard offer a window into an arcadia of luxury and pleasure, and are some of the delights that the Wallace Collection offers to twenty-first-century visitors. With the dispersal of works of art in France following the French Revolution, the uniqueness of the Wallace Collection has always been how French eighteenth-century decorative arts and paintings can be admired alongside one another, in a way that is not even possible in France.

Throughout its history, the Wallace Collection has been beloved by artists and creatives. At first glance, the much-loved films imagined by the legendary Walt Disney and his pioneering hand-drawn animation studio may seem far removed from the stunning eighteenth-century collections in Hertford House but, although separated by two centuries, the artists, craftsmen and animators behind both art forms all had the same ambition – to breathe life, character, and charm into the inanimate.

This exhibition highlights Walt Disney's personal fascination with France and French culture, and shows how the artists behind some of the most iconic Disney films looked to French rococo artworks for inspiration. Setting up a studio in Goodge Street, around the corner from the Wallace Collection, it is likely that the small group of artists behind *Beauty and the Beast* (1991) were directly influenced by the magnificent works in the Wallace Collection galleries. The team working on later films, *Tangled* (2010) and *Frozen* (2013), once again returned to the Wallace Collection art as a source of inspiration, with one of our most famous paintings, Fragonard's *The Swing*, making a cameo appearance.

I am indebted to Wolf Burchard, Associate Curator of European Sculpture and Decorative Arts at the Metropolitan Museum of Art, who came to us with the idea for this show of juxtaposing Disney's hand-drawn animations with the Wallace Collection's French eighteenth-century decorative arts in autumn 2017, when he was still working

at the National Trust. Helen Jacobsen, formerly Curator of French Eighteenth-Century Decorative Arts at the Wallace Collection, and author of this iteration of the Disney catalogue, was as enthusiastic as I was and we are delighted to have been able to collaborate for the first time with the Metropolitan Museum of Art on this landmark exhibition. My warmest thanks to Max Hollein, the Marina Kellen French Director of the Metropolitan Museum, for nurturing and encouraging this project and bringing it to such a splendid fruition when it first opened to the public in December 2021 in New York. I would also like to thank the Metropolitan's outstanding team whose drive and organisation made the partnership possible, notably Quincy Houghton, Deputy Director for Exhibitions, Gillian Fruh, Manager for Exhibitions and Sarah Lawrence, Iris and B. Gerald Cantor Curator in Charge, European Sculpture and Decorative Arts.

The most important lender to this exhibition has of course been the Walt Disney Animation Research Library, whose collections of illustrations, story sketches, concept art and films have generously been made available to us. Our grateful thanks go to the team there, especially to Mary Walsh, Managing Director, and Kristen McCormick, Art Exhibitions and Conservation Manager. The exhibition has also benefitted hugely from the contributions of other important lenders such as the Victoria & Albert Museum, London and The Huntington Library, Art Museum, and Botanical Gardens, San Marino, who agreed to part with their wonderful Sèvres turret vases which grace the cover of this book, and who joined as an exhibition tour venue.

We have loved working with Tom Piper, Theatre Designer, and Alan Farlie, Co-Founder and Director, RFK Architects, on the design of this exhibition – their vision and flair has brilliantly united the worlds of Disney and the decorative arts, contributing a playfulness that is so in keeping with both. Thank you to Sara Jones for the stylish graphics and to Emma Thompson and the team at Imagineear for another fantastic multimedia guide to accompany the exhibition.

This beautiful catalogue would not exist without the skill and dedication of Clare Martelli and Natasha Collin at Philip Wilson Publishers and Ocky Murray's expert design – thank you for another successful collaboration.

For the Wallace Collection, who have been organising international loan exhibitions for three years now, a project such as this show has been an exciting challenge that requires significant work from every department. I would like to thank and congratulate everyone involved. Thanks to Clare Simpson, Head of Exhibitions and Displays, and Edith Brown, Exhibitions Officer, who oversaw the making of the exhibition and catalogue. I am grateful to the Curatorial and Collection Care teams for enabling us to draw so heavily on key works from the Collection for this exhibition. Thanks are also due to Félix Zorzo, Curatorial Assistant, Cassandra Parsons, Photographer and Digital Assets Manager, and Alexander Collins, Research and Content Producer.

We are tremendously fortunate that this exhibition has been funded by some of our closest and most longstanding supporters of the Wallace Collection. We could not have achieved this without the support and tremendous generosity of Adrian Sassoon, Michele Beiny Harkins, Jake and Hélène Marie Shafran, Michael and Angela Cronk, The Rothschild Foundation, The Tavolozza Foundation, Marilyn and Lawrence Friedland, Kate de Rothschild Agius and Marcus Agius. The beautiful images, words and pages ahead were made possible thanks to the loyal and ever supportive, Elizabeth Cayzer Charitable Trust.

Enjoy the magic!

Dr Xavier Bray, Director

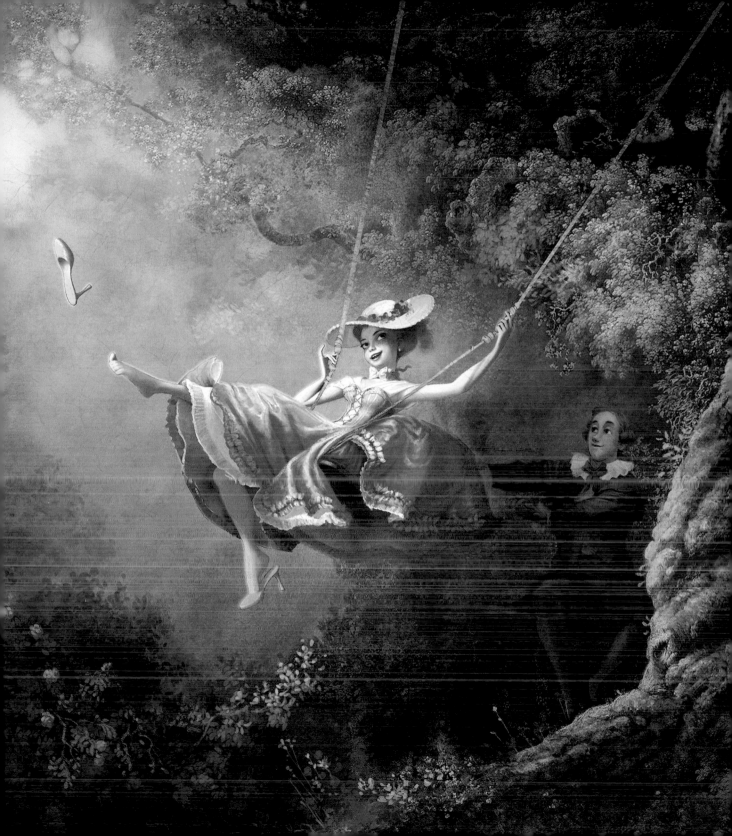

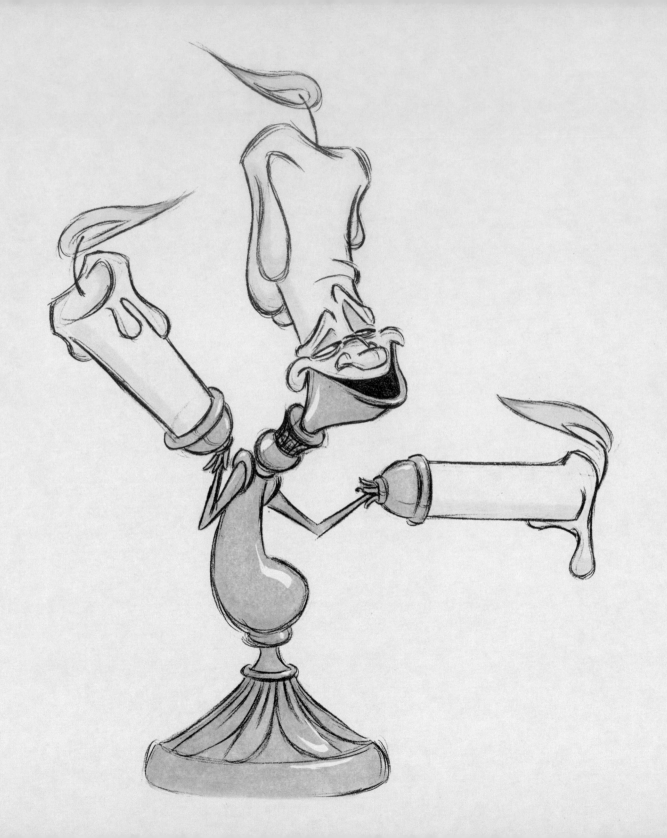

Inspiring Walt Disney

THE ANIMATION OF FRENCH DECORATIVE ARTS

AT THE WALLACE COLLECTION

IN THE SUMMER OF 1989, a small group of Disney artists assembled in a studio in Goodge Street, not fifteen minutes' walk from the Wallace Collection, to discuss the development of a new film. Based on a French moral tale from the 1740s, *Beauty and the Beast* (1991) was to become a critical and box-office success, a major contributor to what became known as the 'Disney Renaissance' of the 1990s. This was a period of renewal for the fortunes of traditional hand-drawn animation, the ground-breaking development in cinema that Walt Disney (1901–1966) himself had done so much to perfect with the films produced by his studios since the 1920s, but which was eventually to be superseded by computer-generated imagery (CGI) at the end of the twentieth century. With *Beauty and the Beast*, the combination of a heart-warming fairy tale, a witty script, catchy musical numbers and spectacular animation effects proved a hit, and it was soon turned into a Broadway musical and a subsequent live-action film.

The artists in Goodge Street looked far and wide for inspiration, visiting London museums and developing their ideas. The intention was to set the film in eighteenth-century France, for which the Wallace Collection's galleries of French painting and decorative art provide endless sources of inspiration. This was not the first time that the European visual tradition was called upon for the setting of a Disney animation and nor would it be the last. Walt had been a voracious collector of eighteenth-century fairy stories from France, Germany and Britain, and under his leadership the output of the Walt Disney Studios was deeply rooted in the history of the 'Old Continent'. This can be seen in the costumes, the architecture and the decorative arts depicted in his studio's films both before and after his death, from *Snow White and the Seven Dwarfs* (1937) to *Frozen 2* (2019).

There is, however, a more fundamental connection between the artistry of hand-drawn animation and the visual traditions of the French

eighteenth century – with consummate skill, a complete understanding of their materials and a touch of genius, both succeeded in animating the inanimate. Later, in the next century, this eighteenth-century style was to become known as the Rococo. Contrary to most artistic movements, the Rococo was born in the decorative arts: the so-called minor arts became the major arts. By pushing the boundaries of shape and form, of ornament and plasticity, of conformity and symmetry, artists such as Juste-Aurèle Meissonnier, Jean-Claude Chambellan Duplessis and Jacques Caffieri broke the rules and changed the direction of artistic production and interior decoration. The style spread across Europe, its popularity driven by its novelty and whimsy, and over a century later its impact was still being felt in later iterations such as the nineteenth-century Rococo Revival and even Art Nouveau.

This exhibition, a partnership between the Wallace Collection and the Metropolitan Museum of Art, seeks to celebrate the joy and mastery of both Disney animation and the French Rococo, art forms which, it may surprise visitors to learn, have much in common. Using material from the two museum collections and three of the historical collections preserved by The Walt Disney Company, as well as loans from several other generous lenders, the exhibition draws remarkable comparisons between Disney's striking designs and highly significant works of French art, exploring the shared desire of the artists to breathe life into objects, to entertain their public and to use new technologies to help achieve their aims.

Walt Disney and Europe

Although closely associated with American popular culture of the twentieth century, Walt Disney was fascinated by Europe and much of his work reflected European literary and visual traditions. He crossed the Atlantic many times, first travelling to

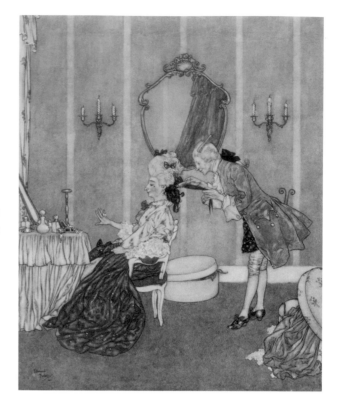

Fig. 1 Edmund Dulac, *Cinderella's step-sister at her toilette*, from *The Sleeping Beauty and Other Fairy Tales from the Old French*, 1910

France in 1918, just after the conclusion of World War I, having enrolled with the Red Cross as an ambulance driver. Returning to the USA the following year, he started his artistic career in commercial illustration but soon left to pursue his interest in cartoons and animation. By 1923 he had, with his brother Roy, set up the Disney Brothers Cartoon Studio – later to become The Walt Disney Company – in Los Angeles. There they created various short films, including a combination of live-action and animation, but it was Mickey Mouse, a character Walt developed with animator Ub Iwerks in 1928, that brought him commercial success.

By the time he arrived in London in the summer of 1935 for a European 'grand tour' with his family, he was welcomed everywhere as a cinematic pioneer superstar. In Paris, Walt visited the historic sites including the Palace of Versailles, where family home movies show him exploring the park, Louis XIV's spectacular Hall of Mirrors and Marie-Antoinette's private apartment. Walt's imagination was clearly sparked by European fairy tales and during this trip he began to put in place what would become a reference library for the Disney Studios' artists: over 330 books on European art and architecture and, above all, many richly illustrated fairy tales, fables and bedtime stories, including *Cinderella*, *Sleeping Beauty* and *Beauty and the Beast* (fig. 1). As well as acquiring books, he was also fascinated by the world of miniatures – miniature furniture and household objects, such as ceramics, stoves, candlesticks, cutlery and clocks, and he even made

miniature furniture himself. During his visits to Europe, he delighted in adding to his collection, for example visiting the Marché aux Puces (a street market) in Paris. His collection of miniature plates reveals a taste for the sentimental and even kitsch, many decorated with couples in eighteenth-century dress loosely based on the French tradition of *fête galante* painting. After World War II he returned to Europe regularly, visiting Paris and London numerous times over the following two decades.

The Art of Storytelling

Walt's genius was to harness the power of storytelling to a new medium. With these European tales, the development of new animation techniques and the introduction of sound, Walt pushed the boundaries of animated films with full-length features like *Snow White and the Seven Dwarfs*, *Pinocchio* (1940) and *Cinderella* (1950), and became a household name.

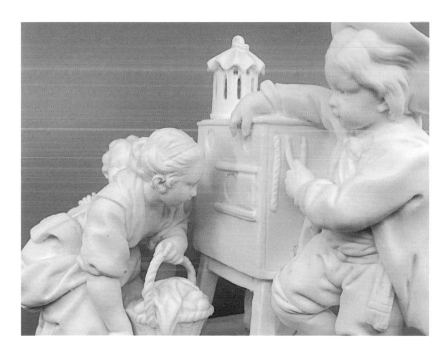

Fig. 2 Modelled by Étienne-Maurice Falconet, Sèvres Porcelain Manufactory, detail from *The Magic Lantern*, c. 1760

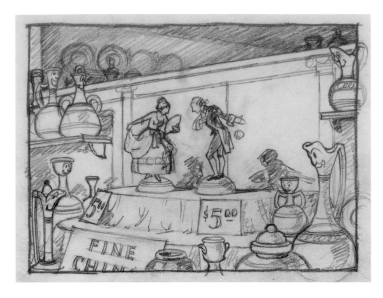

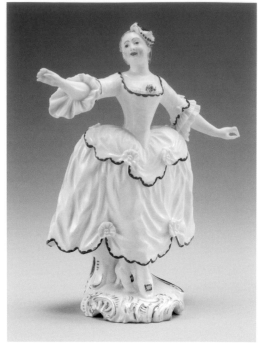

Fig. 3 (above) Disney Studio Artist, *The China Shop* (1934), story sketch, *c.* 1933

Fig. 4 (right) Johann Friedrich Lück, Höchst Manufactory, Dancer, *c.* 1758

In a comparable fashion, the introduction of the magic lantern in eighteenth-century Europe revolutionised storytelling and captured the imaginations of earlier audiences. A development of the camera obscura, these 'lanterns' were small image projectors that used a painting or print to tell a story and which became common sights at fairs and markets where they were displayed by wandering entertainers and storytellers, in effect the very early precursors to cinema. Artists depicted such scenes in paintings and in print, and even in porcelain (fig. 2).

Étienne-Maurice Falconet's charming porcelain group was not only a representation of a technical innovation, the magic lantern, it was itself modelled in a novel material. The manufacture of porcelain had been introduced in Europe in the early eighteenth century, and the Vincennes/Sèvres Manufactory on the outskirts of Paris had only recently introduced these so-called 'biscuit' figures

in unglazed soft-paste porcelain when Falconet was hired to be the director of the sculpture workshop in 1757. Intended to decorate the centre of a dining table, or to be placed as stand-alone sculpture groups, the figures became a commercial success for the factory. Just as the new medium provided novelty and freshness for buyers of porcelain, the delightful expressions on the children's faces in Falconet's group remind us of the sense of wonder and excitement produced by this pre-cinematic lantern show – the same emotions ignited by the animated films of Walt Disney.

Animated porcelain, furniture and clocks were important actors in Walt's films from the early days of his success. The *Silly Symphony* series of short films that ran between 1929–39 included *The Clock Store* (1931) and *The China Shop* (1934), in each of which decorative art objects spring to life and become the main characters of the story. Anthropomorphic

clocks, vases, crockery and porcelain figures cause mayhem, their physical features amusingly exaggerated to suggest human physiognomy – smiling clock faces, chubby round jugs like naughty schoolboys and elegant pear-shaped vases – while the all-important musical soundtrack reinforces their actions (fig. 3). The main protagonists in *The China Shop* are a couple of porcelain figures modelled in the manner of eighteenth-century examples such as those made at many European porcelain manufactories, including Meissen and Höchst. Disney's innovations in this and other short films included the use of Technicolor, which added a new dimension to his cartoons, while the European porcelain manufacturers constantly extended the capabilities of their new medium. The figures produced by Höchst, unlike those at Sèvres, were glazed and decorated with enamel colours. Similar to Sèvres, however, the modeller Johann Friedrich Lück referenced real-life events for his inspiration: in one case, a French celebrity, the dancer Marie Sallé, whose fame was international (fig. 4).

The parallels between eighteenth-century porcelain manufactories and the developments at Disney are not limited to the introduction of new techniques to produce new art forms. Both relied on integrated workshops, or studios, with many artists working tirelessly together to produce the finished product. At Disney, literally hundreds of artists were employed. The initial concept art – including the 'look' and palette of the film – went to the Story Department where the narrative was developed, while other artists worked on the characters, the layout, the animation and the special effects. The employees in the Ink & Paint Department painstakingly transferred the finished drawings onto transparent sheets of celluloid, or cels (every second of a film required 24 drawings), and camera operators and the production team brought it all together into the seamless sensory experience of the finished film. Similarly, in the early porcelain workshops, an artist's initial 'concept' drawing was turned into a shaped, glazed, decorated and gilded piece of porcelain by a host of modellers, throwers, painters, enamellers, gilders and technicians who harnessed only the heat of a furnace to transform the clay into a highly prized – and often highly priced – porcelain object. At Vincennes/ Sèvres, which is exceptionally well documented, women were a large part of the skilled workforce, producing uniquely naturalistic porcelain flowers and applying painted decoration. It is hard not to make the comparison with the Ink & Paint Department at Disney which, for many decades, was staffed primarily by women.

Cinderella

Three female artists – Bianca Majolie, Josephine 'Fini' Rudiger and Mary Blair – worked on the concept art for *Cinderella*, a film which gave new life to an old fairy tale and brought it into mainstream popular culture. Majolie's early

Fig. 5 Bianca Majolie, concept art of Cinderella fleeing the ball for *Cinderella* (1950)

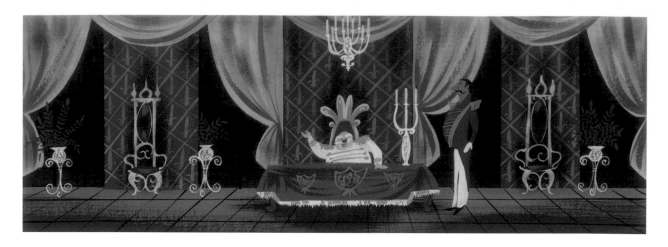

Fig. 6 Mary Blair, concept art of the King
at dinner for *Cinderella* (1950)

pastels date from the late 1930s and demonstrate
a familiarity with the illustrations by Edmund
Dulac and Félix Lorioux that were published in the
French editions of *Cendrillon* which Disney had
brought back from France in 1935 (fig. 5). With
other artists, she worked on character development,
using exuberant eighteenth-century fashions to
help convey humour in the key figures. Although
specifically French in atmosphere, the later concept
art by Mary Blair – one of the greatest colour
stylists to work at Disney – and subsequently
Claude Coats, along with other key colour stylists,
moved the visual reference to the nineteenth century,
with military-style tunics and short hair for the male
characters rather than silk waistcoats and frock
coats (fig. 6). This may have been because of the
technical difficulties in animating lavish gowns and
layers of lace, bows and embroidery, but may also
have been a reflection on contemporary perceptions
of masculinity. Blair's gouache sketches for the sets
reflect not eighteenth-century interiors but those of
Second Empire Paris, themselves an interpretation
of the Rococo of the previous century and well

suited to the artist's elongated style and exaggerated
proportions. The furniture and decorative art of the
background art eventually used for the film, with its
even more exaggerated curves and proportions, is
perhaps more in keeping with the Rococo Revival
of the *fin de siècle* and America's Gilded Age.

The handling of the spatial dimension in the
background art produced for *Cinderella* is striking
and a reflection of the demands of animation.
While it was possible to give three-dimensionality
to cartoon characters and spatial depth to their
actions, it was harder to do this with the two-
dimensional painted backgrounds. The development
of the multiplane camera in the late 1930s helped
with this, allowing for multiple glass plates, each
painted with an element of the scene's setting,
to be stacked on top of each other and moved
independently to create depth in the scene, rather
in the manner of theatrical stage scenery.

Blair's concept art for Cinderella's transformation
by her fairy godmother presented a real challenge
to the animators. Blair had painted the godmother
waving magic fairy dust over the pumpkin and
Cinderella's dress, turning them into a carriage and
ball gown in a flurry of sparkles and light (fig. 7). But
how to get that effect on film? The effects animators

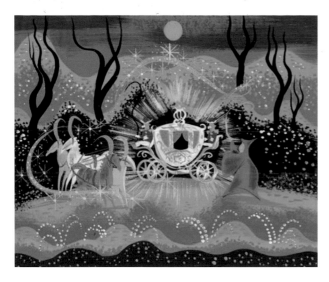

Fig. 7 (above) Mary Blair, Cinderella's magic carriage, concept art for *Cinderella* (1950), 1940s

Fig. 8 (right) Marc Davis (character) and George Rowley (effects), Cinderella's transformation, *Cinderella* (1950), late 1940s

and character artists produced a memorable moment in cinematic history (and, reputedly, Walt's favourite scene) through an extraordinarily disciplined and sophisticated sequence of drawings in which literally thousands of pencil marks representing the magic dust, all exactly positioned on multiple different sheets, were superimposed one after the other to create the special effect (fig. 8). Once these had been transferred and painted onto cels with similar exactitude by the women of the Ink & Paint Department, the scene was filmed and Cinderella's dazzling transformation achieved.

Architecture of the Imagination

The architecture of the castles in Disney's animated films is part of the long tradition associating Gothic architecture with highly charged, emotional storytelling, a tradition which stretches back to the British eighteenth-century tales of Horace Walpole and William Beckford and the literary and artistic Romantic movement of the following century. This architecture also helped inform the real-life castles that were later built at Disney theme parks, although the direct inspirations for these are multiple, not least the spectacular Schloss Neuschwanstein built by Ludwig II of Bavaria. The early visual development for the castle in *Cinderella*, however, displayed a specifically French influence in keeping with the French setting of the story, even an explicit reference to the architecture of the Palace of Versailles. French sources were later mined for the treatment of the Beast's castle in *Beauty and the Beast*, including an interpretation of Versailles's spectacular Hall of Mirrors used as a model for

the ballroom (fig. 9). An early drawing for the ballroom in *Cinderella* similarly owed more to the Baroque architecture of the seventeenth century, but it is to the eighteenth century that the studio artists turned for more ideas for *Beauty and the Beast* as the exquisite miniature watercolour by Gabriel-Jacques de Saint-Aubin makes clear (see pp. 52–3).

The development for the interior of the Beast's castle combined many different visual references, including the French Baroque and Rococo traditions. In addition to providing the inspiration for the narrative, Disney artist Hans Bacher's concept pieces conveyed much of the excitement, drama and fear that the film evokes, even without the presence of the leading characters. Through dramatic perspectives, exaggerated light and shade, and rich colour, Bacher's works heighten the tension and help move the story along. The dramatic effects of a tightly spiralling turret staircase were exploited with great effect (see p. 49), just as they were in the artwork of the finished film.

In eighteenth-century France, the fashion for turrets and fortified houses had long since faded, and contemporary architecture was in the classical tradition. Castle turrets were thus perhaps an unlikely inspiration for Sèvres, and the novelty of the two pairs of vases '*pot pourri entouré*' (so-called 'tower vases') produced in *c.* 1762–3 is remarkable (see pp. 47–8). Each vase is modelled as a fortified tower, with buttresses supporting the top of the body and tiny cannons poking out beneath, the lid taking the form of a high dome with dormer windows decorated with exploding cannon balls, while a cupola acts as a finial. The enamelled decoration on both pairs is of the highest quality, with painted floral garlands and military trophies, while the strong ground colours – green

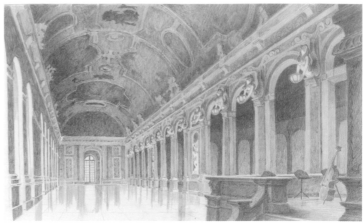

Fig. 9 Mike Hodgson, Hall of Mirrors, Versailles, concept art for the ballroom in *Beauty and the Beast* (1991), *c.* 1990

on one pair, pink and blue on the other – add to the striking effect. The Sèvres records provide no clues about the patron or patrons, but the scale and quality of the decoration leave no doubt that they were important creations, even special commissions, and the date of manufacture suggests that they may have been related to the ending of the Seven Years War. They represent the whimsy and technical prowess of Sèvres at its very best, a flight of fancy just as evident as that displayed in the castles of *Cinderella* and *Beauty and the Beast* two hundred years later.

Animating the Inanimate
Cinderella was not the only French fairy tale to inspire Disney. The literary fairy tale was a genre that had developed in France in the 1690s and was very much associated with women writers. *Beauty and the Beast* is perhaps one of the most popular fairy tales of all time, having been turned into musicals, ballets, plays and even a film before Disney alighted upon it, but it was

originally published by Gabrielle-Suzanne Barbot de Villeneuve (1685–1755) in 1740. At a time when female-authored books did not receive the same acclaim as those by men, she chose to publish anonymously, and this may be one of the reasons why her name has been all but forgotten. Less than a year after her death, another female author, Jeanne-Marie Leprince de Beaumont (1711–1780), famous for her epistolary and pedagogical works, plagiarised the story in an abridged version of the tale, and it is most often she who is the credited author, if one is acknowledged at all. The story is characteristic of the so-called 'transformational literature' of mid-eighteenth-century France: novels which were written for adults and were characterised by objects and people falling under magic spells, transforming them into other beings from which they could only escape through the power of good deeds, true love, or the expression of moral integrity in some shape or form.

In *Beauty and the Beast*, the handsome prince is turned into a hideous beast and can only return to his human form when a woman voluntarily falls in love with him and asks him to marry her. Villeneuve's tale promotes an ideal love whereby free choice – rather than the arranged marriages that were customary for elite women in eighteenth-century France – is all-important and love is based on generosity and kindness. The leading female characters in the story are powerful, and Belle, not the Beast, is the agent; this was very different to the male-dominated society of eighteenth-century France in which Villeneuve lived. This type of literature was often adopted by authors as a means of inverting contemporary values, or for satirical purposes. In 1742, Claude Prosper Jolyot de Crébillon (1707–1777), the son of the eminent tragedian with whom Villeneuve co-habited, published *Le Sopha: conte moral* (*The Sofa: A Moral Tale*), a satire on the French court and society manners, in which the

hero's soul is condemned to inhabit a succession of sofas until he witnesses a declaration of true love by a couple seated on his sofa-body.

Crébillon's choice of a sofa for his protagonist was itself a parody of modern taste: coming as it did from the Ottoman world, this relatively new form of seat furniture, with its connotations of luxury and intimacy, was to be found in all the most fashionable interiors (fig. 10). In Villeneuve's story, the interiors of the Beast's castle played a part

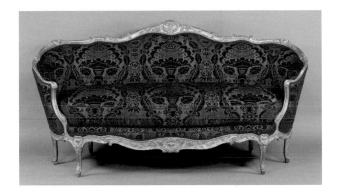

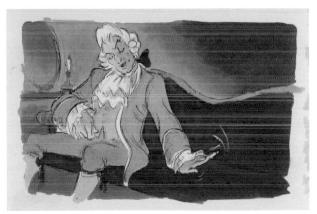

Fig. 10 (top) Jean-Baptiste I or Jean-Baptiste II Tilliard, Sofa (*ottomane veilleuse*), c. 1750–60

Fig. 11 (above) Disney Studio Artist, Gaston invites Belle to sit beside him, story sketch for *Beauty and the Beast* (1991), 1989

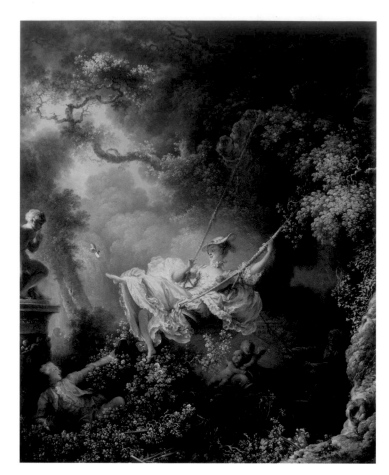

several times throughout his career, but it was not until after his death that the Disney Studios finally produced it as a film. It had been one of the fairy tales he had brought back from France in 1935. Just as with *Cinderella*, the initial visual theme was once again intended to be eighteenth-century France and the early character sketches show the main protagonists – the Beast, Belle and the supercilious Gaston – in silks, bows, lace and feathers. A number of Disney artists including Mel Shaw, Hans Bacher and Glen Keane worked on early storyboards and character sketches, based out of the studio in Goodge Street. It was here that they may have got to know the Wallace Collection and its matchless French eighteenth-century collection of paintings and decorative art, which appear to have provided some of the initial inspiration.

Central to the early storyboards, setting the 'look' of the film and clearly owing a debt to the Wallace Collection's famous painting, were interpretations based on Fragonard's *The Swing* (fig. 12). Both Peter J. Hall and Mel Shaw devised early concept art in which the entire opening scene was based around the painting (see pp. 56–7). It is not hard to see why the work appealed to Disney artists: Fragonard's intimate scene draws the viewer in. The painter has both created the illusion of movement – the to and fro of the swing, the young man sprawling in the undergrowth and, above all, the shoe flying through the air – and shown himself to be a master storyteller. His stroke of genius was to paint the picture in the rococo style which, although by then

in overwhelming the heroine with their beauty and artistry, a theme that was taken to its conclusion in a later novel by Jean-François de Bastide, *La Petite Maison (The Little House)*, of 1758. Both books underline how seminal interior décor and decorative art were in French cultural life in the eighteenth century. In the twentieth century, the place of a sofa in romantic storytelling was reprised by the artists developing the *Beauty and the Beast* narrative, with the arrogant Gaston's attempts to persuade Belle (fig. 11).

Walt Disney himself had looked at producing an animated version of *Beauty and the Beast*

slightly outmoded, enabled him to use painterly techniques and a palette of colours that enhanced the playfulness and vivacity of the painting. It is a masterpiece of storytelling. Even the statue of Cupid is part of the narrative and would have been an amusing reference for contemporaries, who would have known the marble sculpture by Falconet that had been commissioned by Madame de Pompadour and exhibited at the Paris Salon of 1757. This, and the production at Sèvres of a reduced version in biscuit porcelain, would have made the figure widely recognisable (fig. 13).

The way in which Fragonard has created the sense of depth in his painting through the different spatial planes of background, middle ground and foreground is reminiscent of the set designs of eighteenth-century theatre and would have been instantly compelling to Disney artists, used to the background effects of the multiplane camera. In the end, *The Swing* did not make it into *Beauty and the Beast*, but its impact had not been forgotten. Over a decade later, Lisa Keene, who had worked as background supervisor on the earlier film, was inspired to use the painting for her concept studies for a new Disney production, *Tangled*, and three years later the painting finally made it into a Disney movie, as part of the action in the picture gallery of the palace of Arendelle in *Frozen*. For *Beauty and the Beast*, it was another of the Wallace Collection's most famous paintings, Frans Hals's *The Laughing Cavalier*, that appeared in the film, hanging on the walls of the Beast's castle outside Belle's bedroom.

The human desire to anthropomorphise, or to animate inanimate objects, stretches back to prehistory. Walt Disney's early experiences with the *Silly Symphony* series tapped into this, with clocks, jugs, vases, pots and other objects coming to life, while Mickey Mouse had to deal with obstreperous furniture. The success of Mickey himself proved

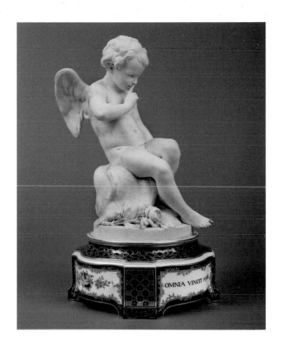

Fig. 13 Modelled by Étienne-Maurice Falconet, Sèvres Porcelain Manufactory, *L'amour Falconet, c.* 1761–3

that attributing human characteristics and emotions to animals could be box-office gold, and subsequent generations of Disney artists have continued to delight and entertain with their inventive characters. With apparent effortlessness, these highly skilled artists manage to breathe life, character and wit into their actors, be they animals or objects.

The plot of *Beauty and the Beast* allowed the artists to play on this animation to its fullest extent. In the story, the Beast's household staff are transformed into candlesticks, porcelain and furniture by an enchantress; the talent of Joe Grant, Brian McEntee, Nik Ranieri, Will Finn, David Pruiksma and other studio artists was to breathe life into these objects, simultaneously conveying both the physiognomy and the personality of the underlying humans in their sketches. Who can

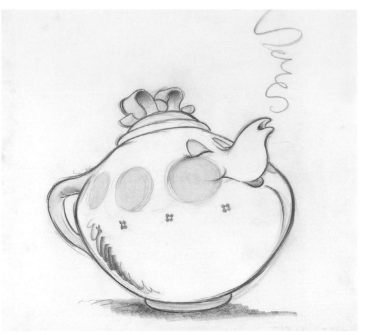

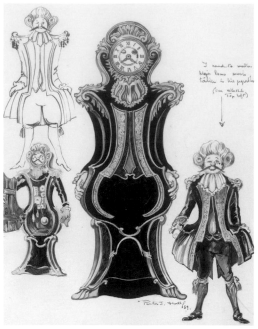

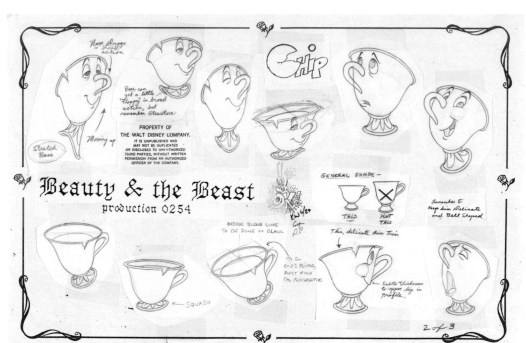

Fig. 14 (above left)
Chris Sanders,
Mrs Potts, concept
art for *Beauty and
the Beast* (1991),
c. 1989

Fig. 15 (left) Disney
Studio Artist,
Chip, model sheet
for *Beauty and
the Beast* (1991),
c. 1990

Fig. 16 (above)
Peter J. Hall,
Cogsworth,
concept art for
*Beauty and the
Beast* (1991), 1989

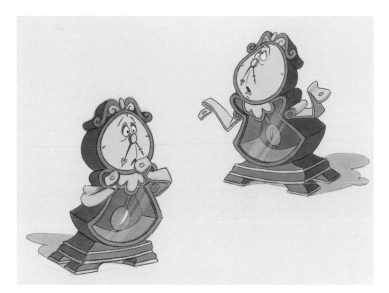

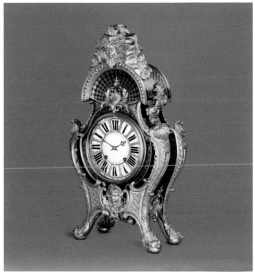

Fig. 17 (above) Brian McEntee, Cogsworth, concept art for *Beauty and the Beast* (1991), *c.* 1990

Fig. 18 (right) Jacques Gouchon (movement maker), bracket clock, *c.* 1730

look at the visual development for Mrs Potts, the round teapot, and not fail to recognise the cheerful, comfortable, motherly figure she really is (fig. 14)? Or see the mischievous schoolboy in Chip (fig. 15)?

It is easy to see the influence of the eighteenth century in these characters. Cogsworth, the Beast's majordomo who finds himself turned into a mantel clock, at one point lectures Belle on the different French artistic styles, although his references to 'minimalist Rococo design' and 'the late-Neoclassical Baroque period' are entertainingly pretentious. Peter J. Hall's preparatory sketches for Cogsworth (fig. 16) drew on the aesthetic of the ebony and gilt-bronze furniture of the early 1700s, such as that by André-Charles Boulle (1642–1732). Cogsworth's black frock coat and breeches, liberally adorned with gold braid and epaulettes, resemble the black and gold of Boulle's furniture and the mottled effect of the scarlet waistcoat and stockings evokes the red-coloured turtleshell found in Boulle marquetry. Although later visual development of Cogsworth portrayed him as a mantel clock (fig. 17), for Disney's live-action retelling of *Beauty and the Beast* (2017) Cogsworth was once again adorned with Boulle marquetry, inspired by the clocks in the Wallace Collection (fig. 18). As is often the case with Disney films, the characters' names are laden with meaning. The double entendre of Cogsworth and Mrs Potts extends to Lumiere ('Light' in French), the vivacious French maître d'hôtel whose object-body is a candlestick. Once again, with quick, simple strokes the artists captured his swaggering personality and loquaciousness in a simple object (see p. 77).

The connection between Hall's character development and Boulle's furniture is significant. Two hundred years before Walt Disney began to animate his cartoons, designers, goldsmiths and furniture-makers had also sought to breathe life into decorative art in a manner that still surprises in its novelty. Striving to break out

from the rigidity and norms of previous artistic traditions, they introduced asymmetry and flowing naturalistic forms to produce decorative art of outstanding originality and technical prowess. It is no coincidence that some of the greatest exponents of the style that was to develop – the Rococo as it came to be called – were goldsmiths by training, since the plasticity of the materials with which they worked lent itself to extreme shapes and fluid lines.

With roots in the early eighteenth century, the style developed in tandem with new techniques and new materials as the masters of their media pushed the boundaries ever further. To achieve the highly sought-after glossy black and gold aesthetic of Asian lacquer, which could not be made in Europe, Boulle perfected the art of veneering his furniture with ebony and metal marquetry, a combination of brass and turtleshell that gave a gleaming black and gold appearance which he augmented further with sculptural gilt-bronze mounts. Boulle further displayed his genius in the design of his furniture, introducing curves where there had been straight lines and pushing the three-dimensionality of his works beyond the bounds of traditional cabinetmaking.

Boulle's gilt-bronze mounts included animal motifs, further enlivening his furniture, such as the expressively-modelled lions' heads and the shaggy paw feet of a small console table, with its animated double-curved legs of a type never seen before (see p. 86). Since the first model of this type of table was made for a pavilion at the royal zoo at Versailles, we can be in no doubt of Boulle's zoomorphic intent. Like the Disney artists, eighteenth-century marquetry cutters also used their medium to tell a story. The top of Boulle's console table displays marquetry with an anthropomorphic theme: monkeys are dressed as humans while walking on tightropes, playing the bagpipes and raising glasses in festive cheer. The two figures

turning the capstan-like wheel – referencing the machinery of the printing press – are clues that the motifs derive from print sources. The story of Diana and Actaeon is depicted in the marquetry surface of a writing desk by Bernard I van Risenburgh (*c.* 1660–1738) (see p. 87). The hunter Actaeon is shown surprising the goddess Diana while she bathes in a fountain. He is turned into a stag by the enraged goddess, who splashes him with water. Inventively, van Risenburgh has used mother-of-pearl to give the water a luminous effect. The

Fig. 19 Detail of one of the legs of a writing table attributed to Bernard I van Risenburgh, *c.* 1715

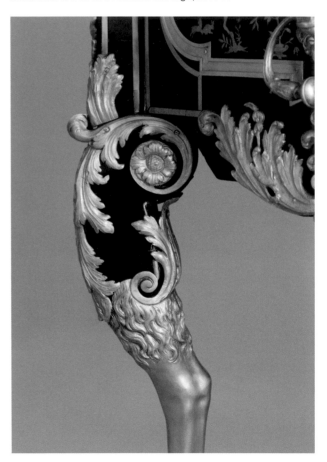

narrative effect is extended to the seemingly bizarre form of the table, which has gilt-bronze zoomorphic legs (fig. 19). Not just Actaeon, it seems, was transformed into a stag.

The animation of objects was taken to a new level by Juste-Aurèle Meissonnier (1695–1750), a metalworker and designer from Turin working in France. His designs for interiors and decorative art ensured that the modern taste (or *goût moderne* as it was known) changed the course of art history. Gone were the traditional classical forms of the seventeenth century, replaced with organic and exuberant shapes and objects. Nowhere were these more clearly evident than in his drawings for silver and metalwork in which the natural world took hold and candlesticks, tureens, gold boxes, coaches, wall panelling and even sofas assumed asymmetric, rocky, shell-like shapes with fluid ornament that merged with form. Meissonnier's reach was not limited to the few patrons in Paris who commissioned his work; through his position as a designer in the royal household, he came to the attention of foreign clients and the publication of his designs in a single volume in 1742 meant that the whole of Europe was soon exposed to his ideas. Metalworkers were at the forefront of this new taste, working in the malleable and sometimes pourable media of gold, silver and bronze (brass). Witty, light-hearted decoration triumphed over traditional conventions, incorporating motifs and forms from the marine and animal worlds. This creativity is superbly illustrated in the snuffbox by the Parisian goldsmith Jean Ducrollay (1710–1787), where opening the simple shell-shaped box transforms it into a stunning peacock's tail in full display (fig. 20).

Although we think of porcelain as fragile, in its unfired form it is a pliable paste. It too embraced the new possibilities of the modern taste, perhaps nowhere more so than at Sèvres, where

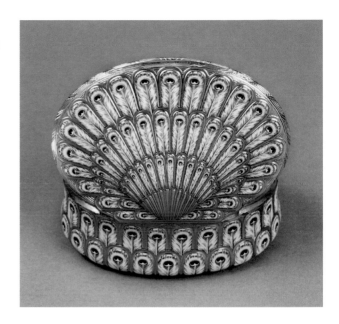

Fig. 20 Jean Ducrollay (goldsmith), snuffbox, *c.* 1744

another Turinese immigrant to Paris, Jean-Claude Chambellan Duplessis (*c.* 1695–1774), became the artistic director of the manufactory in the late 1740s when it was still based at Vincennes. It is probable that he had first-hand experience of Meissonnier's work, and may even have trained with him; he certainly displayed the same brilliance and originality of design. The organic shape of his vase *'à oreilles'* (named after the 'ear' shaped handles that flow out of the body of the vase like splashing water) would have presented considerable difficulties in firing but it is the magnificent ship vase (vase *'pot pourri en navire'*) which impresses most by its technical prowess and design animation (fig. 21). The pennant flutters, the rigging seemingly shudders from the impact of the waves crashing on the base, and the fantastic marine beasts face into the wind, their moustaches streaming either side. Duplessis's work in gilt bronze was no less remarkable and for several decades he produced designs for both media.

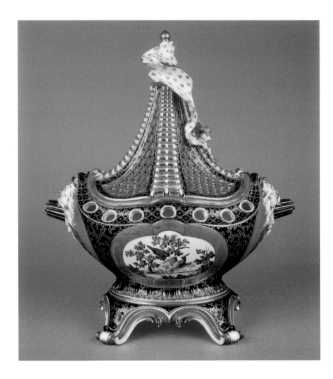

Fig. 21 Design attributed to Jean-Claude Chambellan Duplessis, Sèvres Porcelain Manufactory, ship vase, c. 1761

of firedogs, in which the heads of a lion and a boar burst explosively out of C-scroll rococo ornament. His furniture mounts show the same virtuosity that characterised all the greatest rococo art and which transformed inanimate objects into animated actors of daily life.

The Power of the Imagination

Whether in the literary salons and country fairs of eighteenth-century France or the cinemas of the modern era, the passion for storytelling comes in many guises. Like all great art, at its best it harnesses our emotions and spurs our imaginations, taking us out of ourselves and revealing truths about life and love, making us laugh and cry, surprising and delighting us. Walt Disney fundamentally understood the creative power of the imagination and, together with his artists, he helped make hand-drawn animation into a twentieth-century art form that excited new audiences and broke down barriers. In this respect, Disney mirrors the achievements of the great rococo designers and craftsmen who liberated design from the straitjacket of the previous century's artistic conventions and created a new approach to art, pushing the limits of technology and embracing the imagination. Through their genius they breathed life into inanimate forms, transforming the role of design from an academic discipline into a creative process that displayed genius, daring and – ultimately – a desire to entertain.

It is surely no coincidence that these two trail-blazing rococo geniuses came from Italy, where there was less pressure to conform to the restrictive codes that had ruled the architecture and design of seventeenth-century France. Jacques Caffieri (1678–1755), also of Italian heritage, was a sculptor and metalworker who produced powerfully expressive forms that displayed a mastery of gilt bronze rarely matched. The chandelier made for Louis XV's daughter Louise-Élisabeth, Duchess of Parma, marked a high point in design and execution, with all the naturalistic, organic exuberance associated with the Rococo (Wallace Collection F83). Caffieri demonstrated the same level of originality in a pair

I am extremely grateful to my fellow curator, Wolf Burchard, for being so generous in sharing his knowledge with me and for showing me an early draft of chapters of his book, *Inspiring Walt Disney: The Animation of French Decorative Arts* (Yale University Press, 2021), on which much of this catalogue is based and without which it could not have been written. A list of further reading is on p. 98.

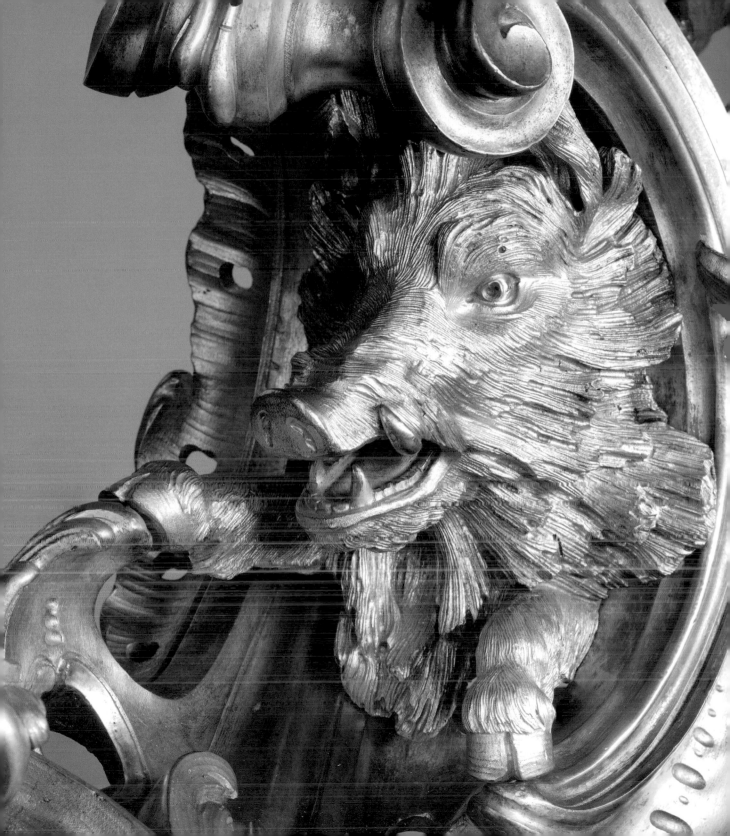

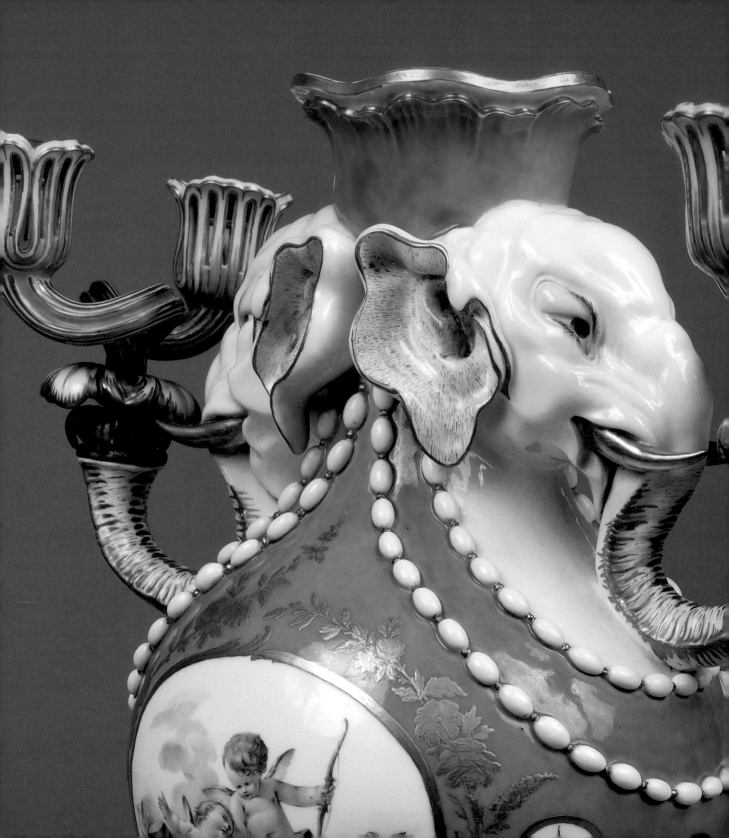

Selected works

When Walt Disney founded his animation studio
nearly a century ago, he could hardly have foreseen
that he would give birth to a global culture with a
far-reaching and long-lasting impact on the visual
arts. This exhibition revolves around two of his
Studios' most successful hand-drawn animation
projects, each based on an earlier French literary
source: *Cinderella* (1950; 1697) and *Beauty and
the Beast* (1991; 1740). It brings together what
may seem two very different worlds: the finest
rococo decorative works of art created for a
small European elite in the eighteenth century,
and twentieth-century animated films made for
a broad, international audience. Yet both forms
of artistic expression benefit from examination in
the context of the other, as areas of overlap are
revealed in everything from humour, craftsmanship
and workshop practices to the exciting advances
each pushed in design and technology.

The Discovery of Europe

Walt Disney's personal discovery of European visual culture at a relatively young age provided him with an inexhaustible source of inspiration from which he drew throughout his life. He first set foot in France on 4 December 1918, just three weeks after the end of World War I, as a Red Cross ambulance driver supporting the U.S. Army. He returned in 1935 for a European 'grand tour' with his family, and by then was welcomed everywhere as a cinematic pioneer superstar.

His imagination was clearly sparked by European fairy tales and during this trip he began to put in place what would become the reference library for the Disney artists: over 330 books on European art and architecture and, above all, many richly illustrated fairy tales, fables and bedtime stories, including versions of *Cinderella*, *Sleeping Beauty* and *Beauty and the Beast*. After World War II, he returned to Europe regularly, visiting Paris and London numerous times over the following two decades.

'Over at our place, we're sure of just one thing: everybody in the world was once a child… So, when planning a new picture, we don't think of grownups and we don't think of children, but just of that fine, clean, unspoiled spot, down deep in every one of us that maybe the world has made us forget, and that maybe our pictures can help recall'.

Walt Disney, 1938

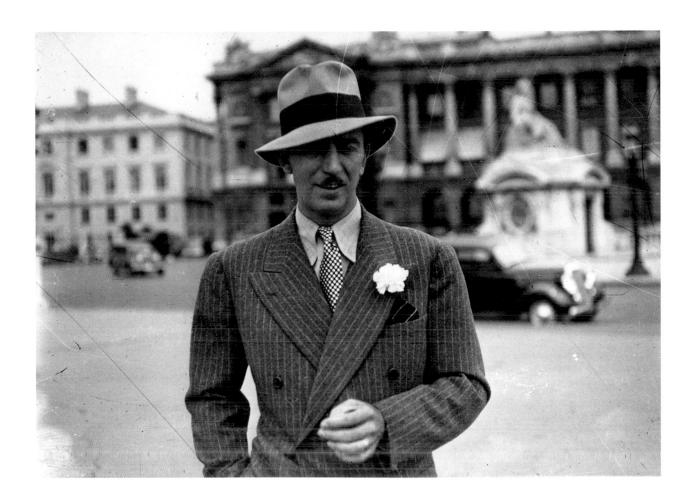

Walt Disney's discovery of European visual culture was to provide inspiration for the rest of his life. After World War II, Disney travelled to Europe regularly, often using these trips to gather new visual references for his studio.

Walt Disney in 1935 on Place de la Concorde in front of Hôtel de Crillon, 1935, Meurisse Press Agency Photograph
BIBLIOTHÈQUE NATIONALE DE FRANCE

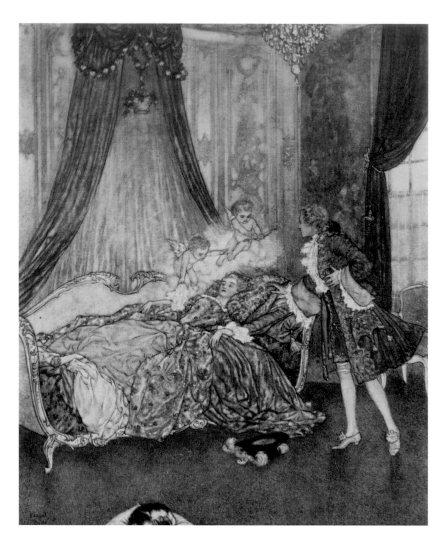

Illustrated fairy tales were part of the collection of over 330 books Walt Disney acquired in Europe, and formed the basis of the Disney studio's reference library.

(left) Edmund Dulac, *Sleeping Beauty*
Published in Arthur Quiller-Couch,
The Sleeping Beauty and Other Fairy Tales from the Old French, London, 1910
Printed paper

(right) Félix Lorioux,
Cinderella and the Prince
Published in Charles Perrault,
Contes de Perrault, Paris, 1927
Printed paper

Walt Disney's genius was to harness the power of storytelling to a new medium. In the same way, the introduction of the magic lantern in eighteenth-century Europe revolutionised storytelling and captured the imagination of audiences. The 'magic' of the title captures not only the excitement of the new technology but also the wonder porcelain inspired in mid-eighteenth-century viewers – similar to the excitement generated by the earliest hand-drawn animated films in the 1920s and 1930s. In rococo Paris, objects such as this one often served as centrepieces for elaborate dinner services.

Sèvres Porcelain Manufactory,
The Magic Lantern, *c.* 1757
Modelled by Étienne-Maurice Falconet,
based on a design by François Boucher
Soft-paste biscuit porcelain
THE VICTORIA & ALBERT MUSEUM, LONDON (414:428-1885)

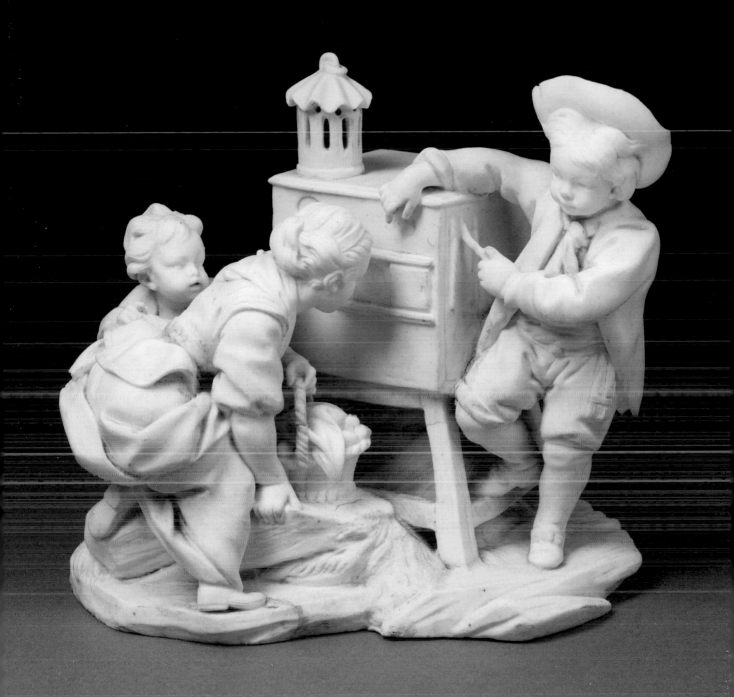

Early Animation

Animated porcelain, furniture and clocks were important actors in Walt Disney's films from the early days of his success. The *Silly Symphony* series of short films was produced between 1929–39 and included *The Clock Store* and *The China Shop*. In both films, decorative art objects spring to life and become the main characters of the story. Anthropomorphic clocks, vases, crockery and porcelain figures cause mayhem, their physical features amusingly exaggerated to suggest human physiognomy – smiling clock faces, chubby round jugs like naughty schoolboys and elegant pear-shaped vases – while the all-important musical soundtrack reinforces their actions. Technically, the *Silly Symphony* series acted as a kind of experimental laboratory.

Disney's hand-drawn animation and eighteenth-century porcelain were both products of extraordinary technical invention and well-orchestrated teamwork. Known as 'white gold' and previously imported to Europe from China and Japan, porcelain was a highly sought-after luxury item and its production first at Meissen from 1710 and then at other European manufactories proved to be a milestone in the development of decorative arts. Combining sinuous curves and asymmetry with vibrant colours and playful ornament, the lively artistic possibilities provided by this medium offered a fresh and witty response to the heavy stylistic language of the preceding decades.

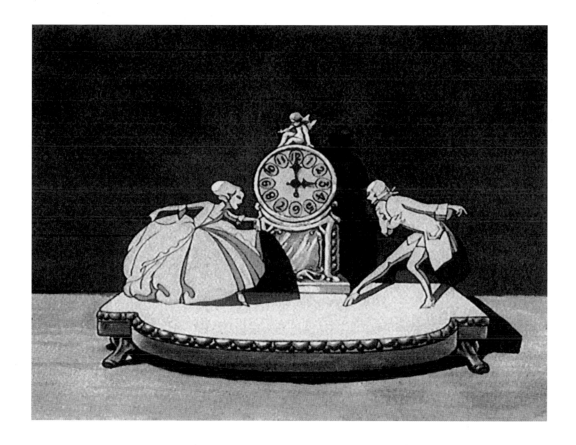

Both *The Clock Store* and *The China Shop* feature dancing porcelain couples of a kind that were immensely popular in eighteenth-century Europe. Here, an elegant mantel clock acts as the stage on which two porcelain figures dance a minuet from Mozart's *Don Giovanni* (1787).

Walt Disney Animation Studios, two dancing porcelain figures from *The Clock Store* (1931)
Film still
WALT DISNEY ANIMATION RESEARCH LIBRARY

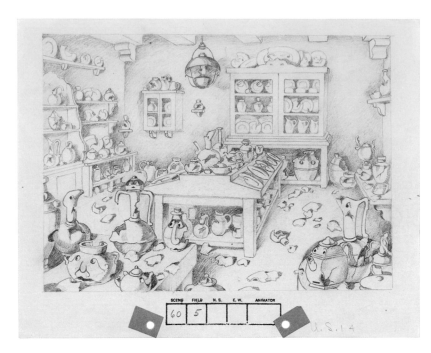

Layout drawings and story sketches give us a glimpse into the early production stages of a hand-drawn animated cartoon. They each outline the individual camera frame. Story sketches were discussed and altered during story meetings, gatherings during which Walt Disney displayed his gift for embellishing narratives, jokes and drama. The drawings have annotations which demonstrate that they were working documents rather than finished works of art.

(left) Disney Studio Artist, layout drawings for *The China Shop* (1934), *c.* 1933
Graphite and coloured pencil on paper
WALT DISNEY ANIMATION RESEARCH LIBRARY

(opposite) Disney Studio Artist, story sketches for *The China Shop* (1934), *c.* 1933
Graphite and coloured pencil on paper
WALT DISNEY ANIMATION RESEARCH LIBRARY

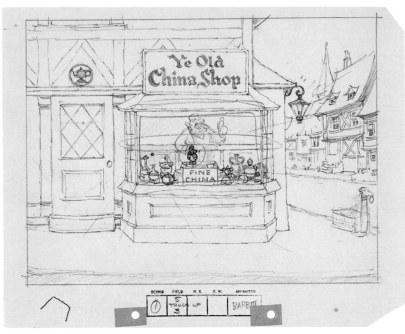

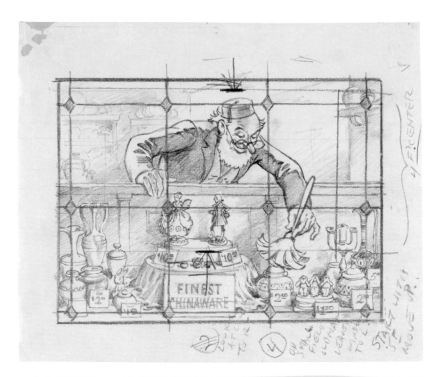

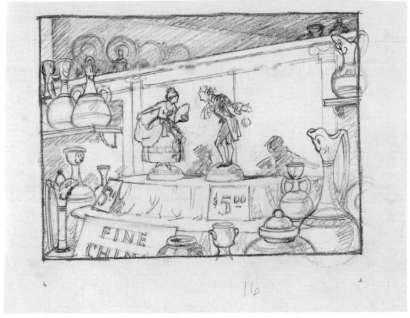

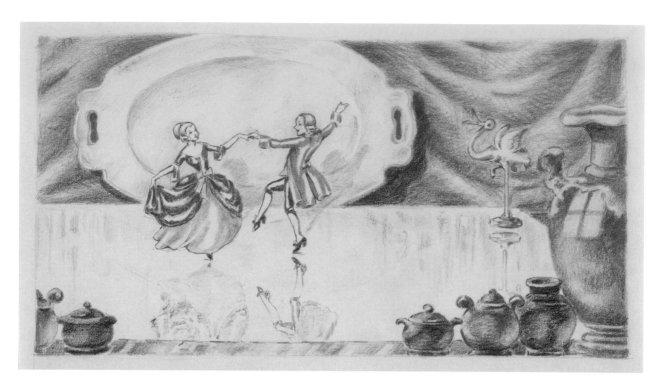

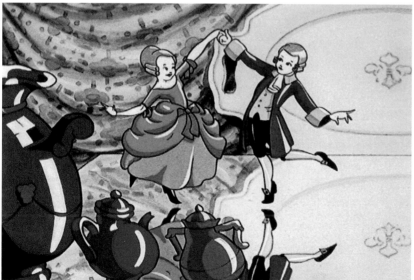

The main characters in *The China Shop* are two porcelain figures who come alive to dance at night after the shopkeeper has gone home, while vases, teapots and plates cheer their performance.

(above) Disney Studio Artist, story sketch for *The China Shop* (1934)
Coloured pencil and graphite on paper
WALT DISNEY ANIMATION RESEARCH LIBRARY

(left) Walt Disney Animation Studios, two dancing porcelain figures from *The China Shop* (1934)
Final frame
WALT DISNEY ANIMATION RESEARCH LIBRARY

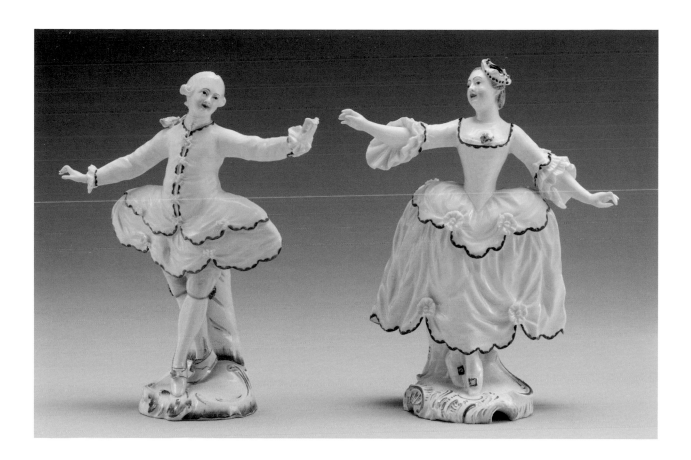

The exaggerated elegance of the figures in *The Clock Store* and *The China Shop*, with elongated limbs and overblown gowns, recall porcelain dancers, such as those produced at the Höchst Manufactory in the mid-1750s. The female figure here is thought to have been modelled on a portrait by Nicolas Lancret of the acclaimed French dancer and choreographer Marie Sallé.

Höchst Manufactory, Johann Friedrich Lück, two dancers, *c.* 1750
Hard-paste porcelain

Cinderella

The release of Disney's first full-length feature film, *Snow White and the Seven Dwarfs* was a milestone in the history of film-making. Never before had a hand-drawn animated movie been more sophisticated or successful.

By the early 1930s, work began on story development of the tale that would ultimately lead to *Cinderella*, based on Charles Perrault's 1697 publication. Walt Disney was eager to repeat the box-office success of the earlier film, but this time it was to be set in 'a small European kingdom' of 'decidedly French' atmosphere. The grand costumes and interiors of the early concept art reflect this, although later the Story Department moved the plot from the eighteenth to the nineteenth century.

The final version of *Cinderella* takes its cue from the late 1850s and the fashions of the French Second Empire, themselves an interpretation of the Rococo of the previous century. Locating the story in a realm inspired by France's Second Empire allowed for sartorial selections that were more palatable for a 1950s American audience – swapping the prince's wig and breeches for a dashing uniform, while still dressing the female characters in dreamy gowns.

Working on the film, and entering the creative realm of the Story Department for the first time at Disney, a small number of talented women played an important role in developing the look and feel of the production. Walt Disney realized the significant contributions that these female artists could make to the film narrative.

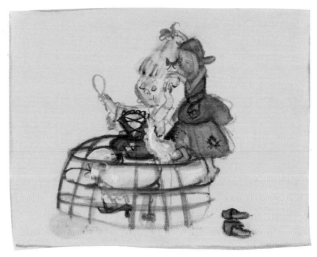

Like the porcelain figures of *The Clock Store*, these early conceptual studies for *Cinderella* present a satirical take on the opulence and femininity of eighteenth-century court costumes.

(left) Disney Studio Artists, designs for the King and Queen, *Cinderella* (1950), c. 1940
Gouache and ink on paper
WALT DISNEY ANIMATION RESEARCH LIBRARY

(right) Disney Studio Artists, designs for Cinderella's stepsisters, *Cinderella* (1950), c. 1940
Gouache and ink on paper
WALT DISNEY ANIMATION RESEARCH LIBRARY

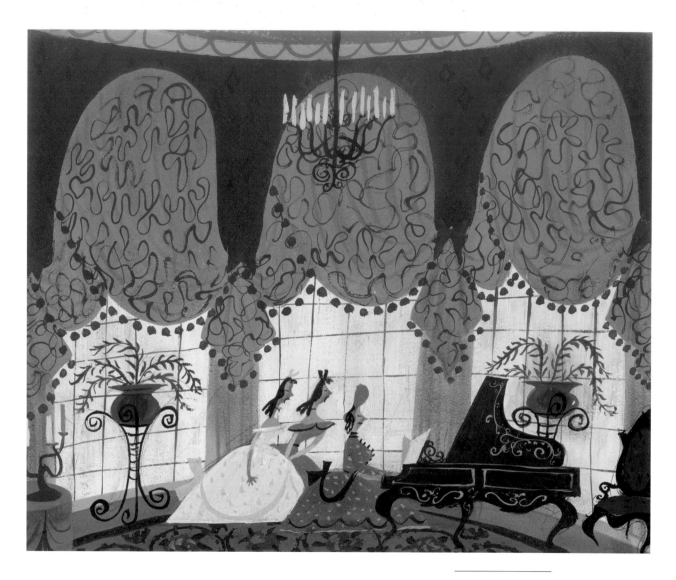

In April 1940, Mary Blair joined the Studios and later took an active design role in the development of *Cinderella*. One of the most celebrated colourists of her time, she had a creative ingenuity that guided the aesthetic feel of the animated features of the 1940s and early 1950s.

(above) Mary Blair, Lady Tremaine and her daughters at the piano, concept art for *Cinderella* (1950), 1940s
Gouache on board
WALT DISNEY ANIMATION RESEARCH LIBRARY

(opposite) Mary Blair, Cinderella looking into a mirror, concept art for *Cinderella* (1950), 1940s
Gouache and ink on board
WALT DISNEY ANIMATION RESEARCH LIBRARY

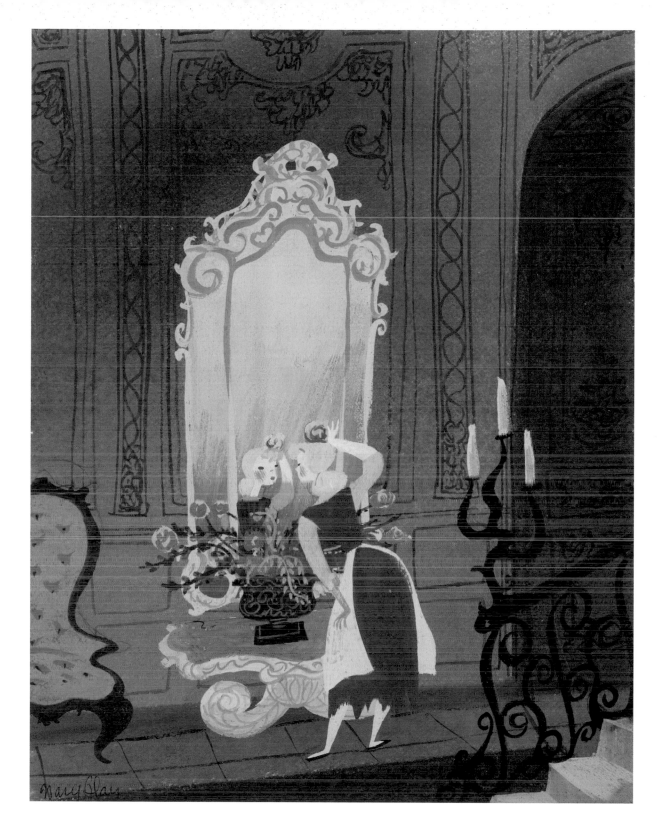

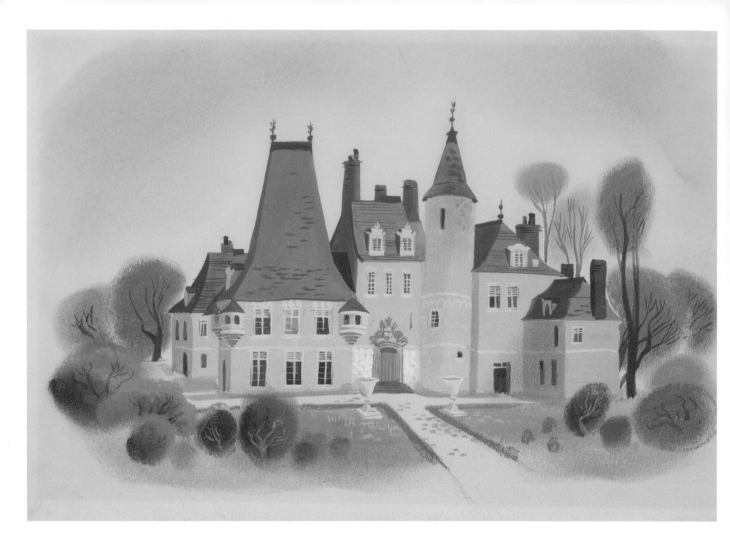

(above) Mary Blair, Cinderella's
father's country château, concept
art for *Cinderella* (1950), 1940s
Gouache on board
WALT DISNEY ANIMATION RESEARCH LIBRARY

(opposite) Mary Blair, Cinderella's
magic carriage, concept art for
Cinderella (1950), 1940s
Gouache, graphite and pastel on board
WALT DISNEY ANIMATION RESEARCH LIBRARY

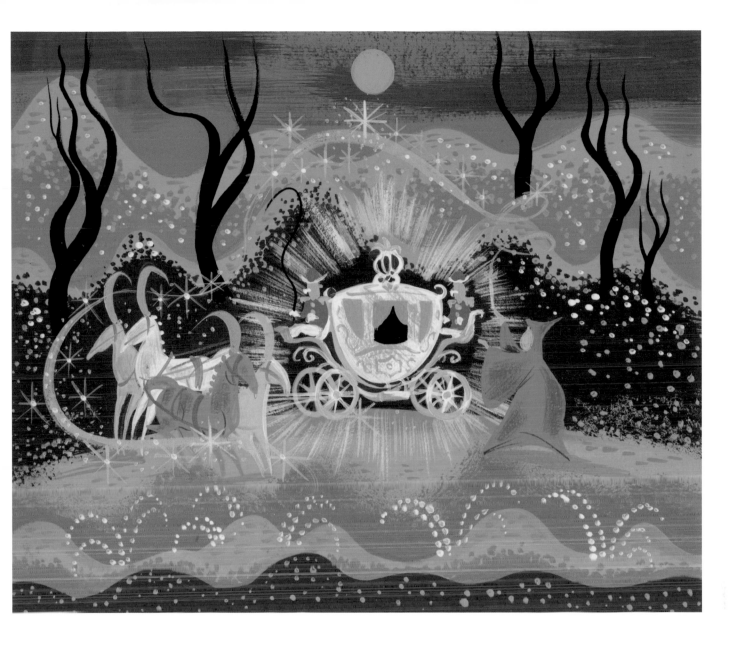

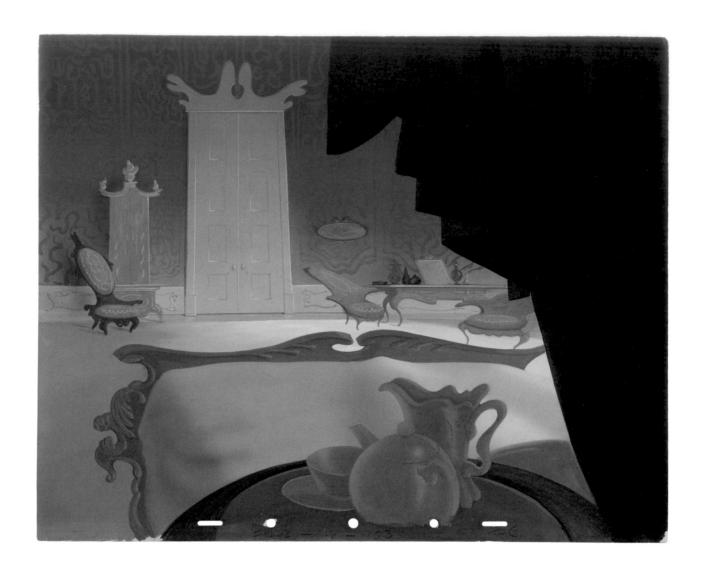

These background paintings demonstrate the studio artists' careful translation of Mary Blair's colour styling for the film's final cut. Here, the colours of Cinderella's stepmother's bedroom pick up on the colour scheme of her dresses.

Disney Studio Artist, Lady Tremaine's bedroom, background for *Cinderella* (1950), *c.* 1948–50
Gouache on board
WALT DISNEY ANIMATION RESEARCH LIBRARY

Disney Studio Artist, background
for *Cinderella* (1950), c. 1948–50
Gouache on board
WALT DISNEY ANIMATION RESEARCH LIBRARY

Twenty-four drawings are required for one second of hand-drawn animation. These two are from the sequence that produced one of the most iconic scenes in the history of hand-drawn animation: Cinderella's transformation. They exemplify the level of attention Disney artists gave to the minutest of details. Under thousands of individually drawn (and later hand-transferred and painted) sparkles, her rags turn into a fine ballgown and she into a radiant apparition. Tradition has it that this was Walt Disney's favourite scene. Many have since read the Disney princess's transformation as the realisation of the 'American Dream' of the 1950s.

Marc Davis (character) and George Rowley (effects), Cinderella's transformation, *Cinderella* (1950), late 1940s
Clean-up animation drawings
Graphite and coloured pencil
WALT DISNEY ANIMATION RESEARCH LIBRARY

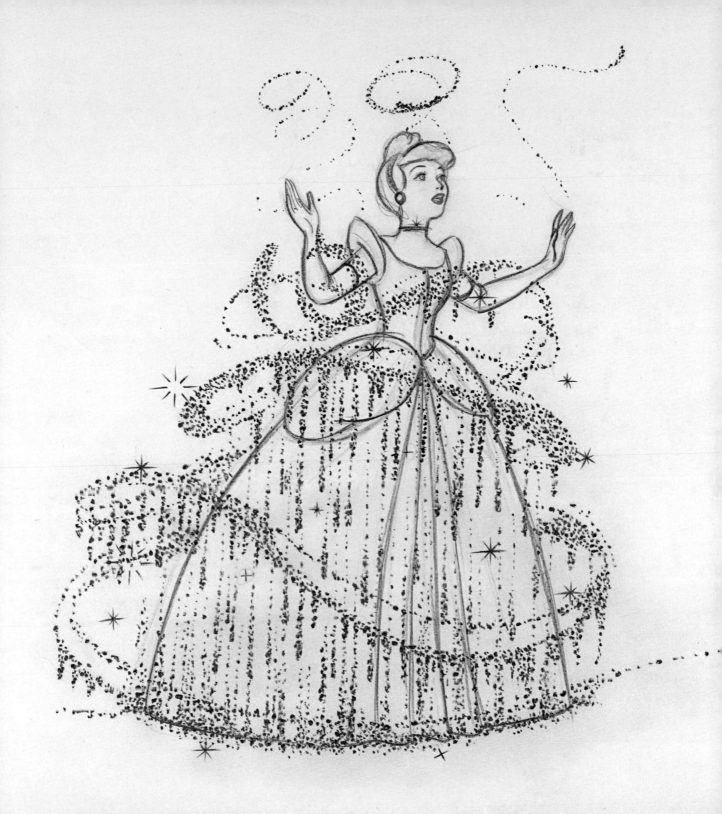

Architecture of the Imagination

In numerous Disney fairy tales, the castle, with its clusters of spirals and steeples, acts as the visual focal point and principal stage set for the story. In line with the eighteenth-century French setting envisaged in the early scripts, visual development for *Cinderella* included studies from French sources, including the Palace of Versailles. Mary Blair's designs, however, were closer to the long tradition associating medieval architecture with highly charged, emotional storytelling.

In the story of *Beauty and the Beast*, the Beast's castle is central to the action. Once again, it was felt that the horizontality, symmetry and order of French palatial architecture did not sufficiently spark the imagination. Although the châteaux of the Loire Valley proved hugely inspirational in the early stages of development, the final structure more closely resembled the more traditional Disney castles with their roots in the romantic Schloss Neuschwanstein in Germany, built by Ludwig II of Bavaria.

The development for the interior of the Beast's castle combined many different visual references, including the Baroque, Rococo and Neoclassical styles of the French eighteenth century. In addition to providing the backgrounds for the narrative, the dramatic perspectives and exaggerated proportions of the visual development conveyed much of the excitement, drama and tension that the film evokes, even without the presence of the leading characters.

Early concept sketches for the castle
in *Cinderella* looked to the Palace of
Versailles, Louis XIV's great palace
outside Paris, for inspiration.

———

Disney Studio Artist, the Prince's
castle, visual development for
Cinderella (1950), *c.* 1948
Ink on paper
WALT DISNEY ANIMATION RESEARCH LIBRARY

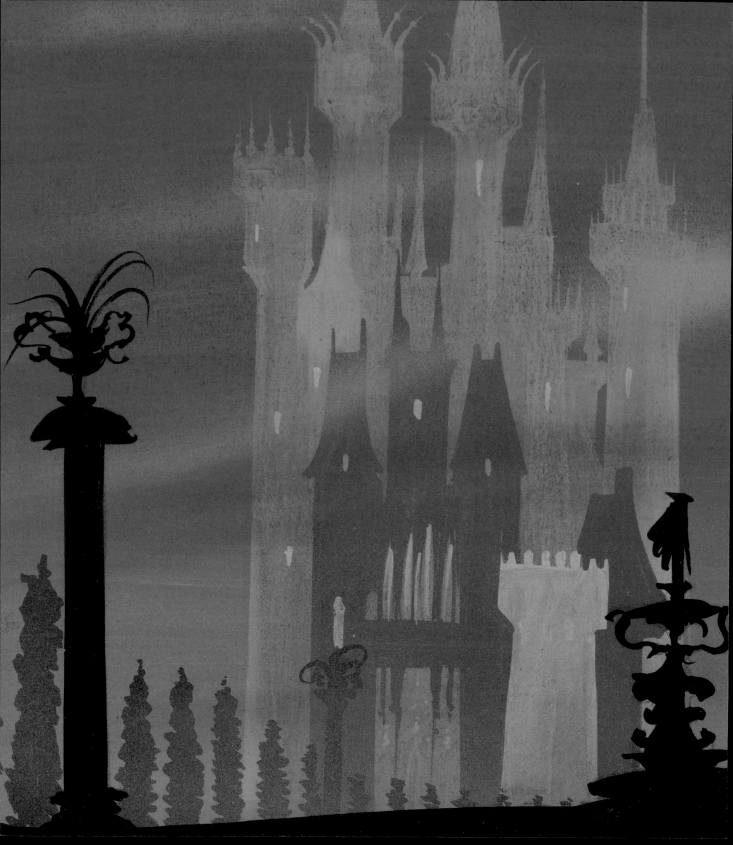

Mary Blair moved the 'look' of the *Cinderella* castle closer to the characteristic 'Disney castle' that we have come to recognise, whether on screen or in theme parks.

(opposite) Mary Blair, the Prince's castle, concept art for *Cinderella* (1950), 1940s
Gouache on board
WALT DISNEY ANIMATION RESEARCH LIBRARY

For *Beauty and the Beast*, the concept art for the Beast's castle displayed the strong influence of the châteaux of the Loire Valley, especially the Château de Chambord.

(top) Hans Bacher, Beast's castle, concept art for *Beauty and the Beast* (1991)
Graphite on paper
WALT DISNEY ANIMATION RESEARCH LIBRARY

(bottom) Hans Bacher, Beast's castle, concept art for *Beauty and the Beast* (1991), 1989
Ink and marker on paper
WALT DISNEY ANIMATION RESEARCH LIBRARY

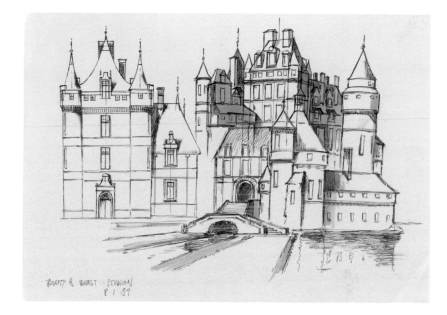

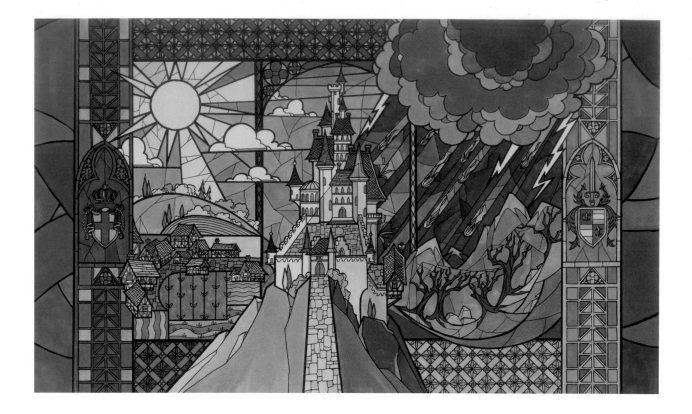

Following more historically based proposals for the Beast's castle, art director Brian McEntee and his team produced a design for a more fantastical fairy-tale castle. A series of stained glass windows fill the opening scenes of the film and are used as a narrative device to perform the introductory role of a storybook.

———————

Brian McEntee and Mac George, stained glass window background of the opening sequence. Reproduction on transparency of xerographic print and marker on cel from *Beauty and the Beast* (1991), 1991

WALT DISNEY ANIMATION RESEARCH LIBRARY

(opposite) These vases are among the most striking ever produced at Sèvres. In the shape of a fortified tower, with small gilded porcelain cannons extending from underneath the buttresses, the lids are formed as high domes with dormer windows, and a cupola serves as the finial. The body is finely painted with trophies of war, composed of various elements associated with military campaigns.

———————

Sèvres Porcelain Manufactory, design attributed to Étienne-Maurice Falconet, pair of tower vases with covers (vases '*pot pourri entouré*'), *c.* 1762 Soft-paste porcelain, painted and gilded

THE HUNTINGTON LIBRARY, ART MUSEUM, AND BOTANICAL GARDENS, SAN MARINO, CALIFORNIA, THE ARABELLA D. HUNTINGTON MEMORIAL ART COLLECTION (27.31, 27.32)

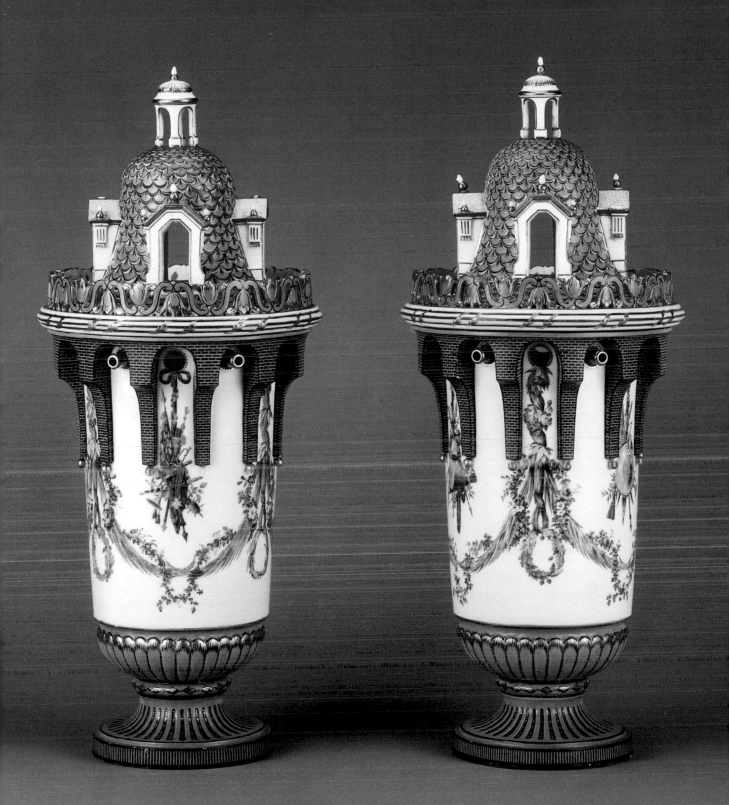

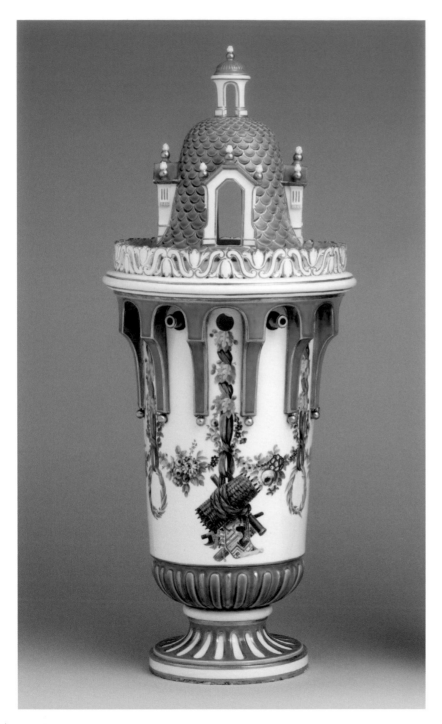

Only two pairs of the tower vases are known. The Sèvres records have left no mention of possible patrons. Although their early history is unclear, the vases reflect the Sèvres factory's ability to create extraordinary objects to entertain and delight their patrons.

Sèvres Porcelain Manufactory, design attributed to Étienne-Maurice Falconet, detail of one of a pair of tower vases (vase 'pot pourri entouré'), c. 1762
Soft-paste porcelain, painted and gilded
THE METROPOLITAN MUSEUM OF ART, NEW YORK, GIFT OF R. THORNTON WILSON, IN MEMORY OF FLORENCE ELLSWORTH WILSON, 1956 (56.80.2A–C)

Hans Bacher's artworks hint at the cinematographic potential of turrets as well as building tension for the storyline.

(opposite) Hans Bacher, Beast's castle, concept art for Beauty and the Beast (1991), c. 1989–90
Gouache on paper
WALT DISNEY ANIMATION RESEARCH LIBRARY

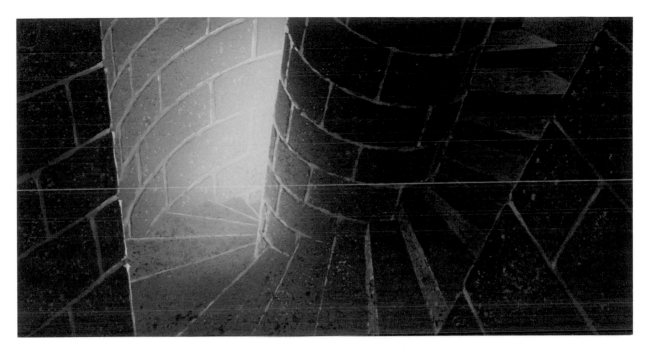

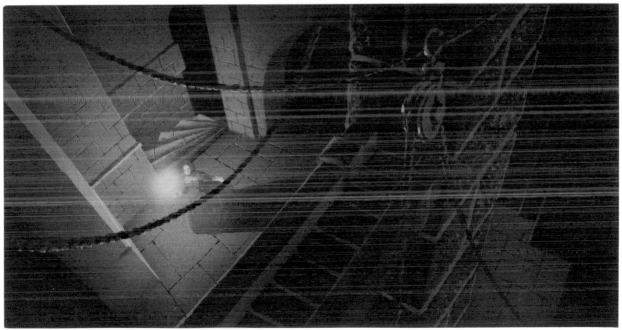

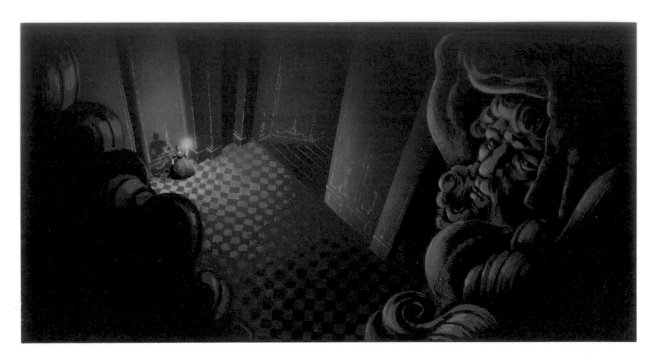

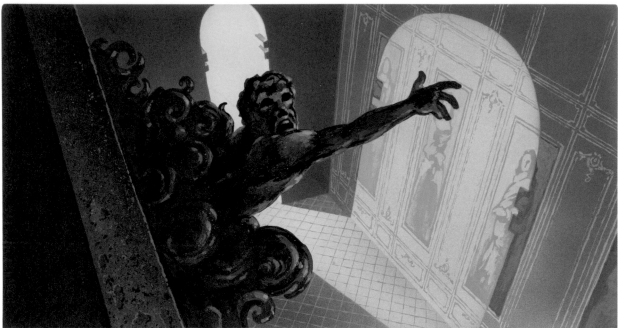

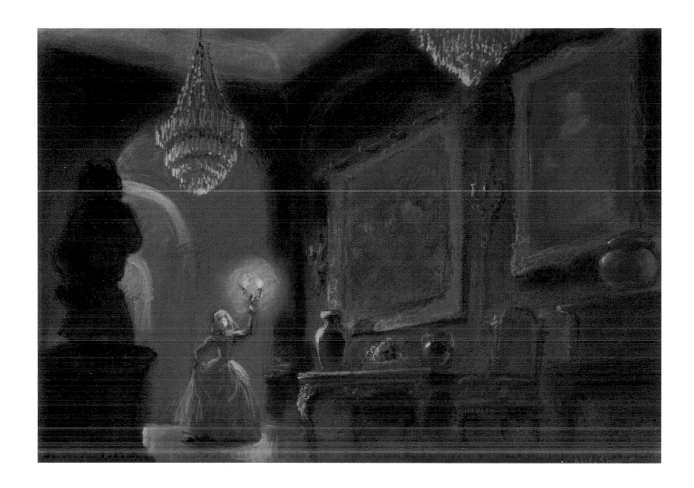

(opposite) The exaggerated proportions
and dramatic lighting of Hans Bacher's
work explore the castle's architecture
from every possible angle and create
a highly dramatic atmosphere.

Hans Bacher, Beast's castle, concept art for
Beauty and the Beast (1991) c. 1989–90
Gouache on paper
WALT DISNEY ANIMATION RESEARCH LIBRARY

Mel Shaw, Belle exploring the Beast's
castle, concept art for *Beauty and the
Beast* (1991), 1989
Pastel on board
WALT DISNEY ANIMATION RESEARCH LIBRARY

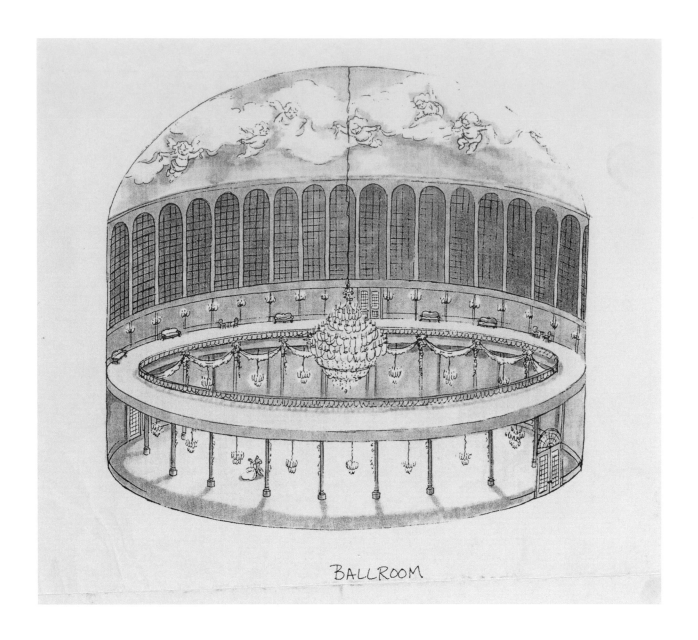

BALLROOM

The magnificent classical ballroom in the Beast's castle, reminiscent of the rotundas for dances and theatrical entertainments of the eighteenth century, was the setting for the Beast's romantic dance with Belle.

Disney Studio Artist, ballroom, visual development for *Beauty and the Beast* (1991)
Photocopy on paper
WALT DISNEY ANIMATION RESEARCH LIBRARY

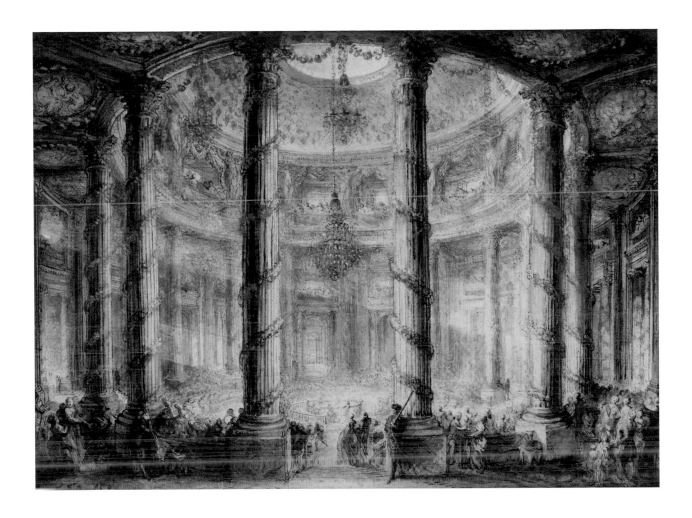

A prolific draughtsman, Saint-Aubin walked the streets of eighteenth-century Paris recording everything he saw. This small watercolour shows a public ball at the Colisée, a luxurious place for public entertainment on the Champs-Elysées that was built in 1770 following the example of London's Vauxhall Pleasure Gardens, and demolished in 1785.

Gabriel Jacques de Saint-Aubin, *A Fête in the Colisée*, 1772
Black chalk, ink, watercolour and gouache on paper
THE WALLACE COLLECTION (P780)

The Swing

Some forty years after the premiere of *Cinderella*, Walt Disney Animation Studios embarked on the production of a new fairy tale, *Beauty and the Beast*. Originally published in 1740 by Gabrielle-Suzanne Barbot de Villeneuve, the story is perhaps one of the most popular fairy tales of all time. Walt Disney, who died in 1966, had considered developing a version of the story several times, but it was not until 1989, when producer Don Hahn gathered a small group of skilled artists in an unassuming studio in Goodge Street in London, that production began in earnest. Hollywood would refer to the years 1989 to 1999 as the 'Disney Renaissance', celebrating the rebirth of hand-drawn animation thought by many to have become extinct.

Not fifteen minutes' walk from the Goodge Street studio hangs one of the most recognizable paintings of the French eighteenth century: Jean-Honoré Fragonard's *The Swing*. The first version of the opening sequence for *Beauty and the Beast* was to show the lead character, Belle, in a pink dress, sitting on a swing, being pushed by her father. It took inspiration from Fragonard's painting and it is not hard to see why his work appealed to Disney artists. Fragonard has both created the illusion of movement – the to and fro of the swing, the young man sprawling in the undergrowth and, above all, the shoe flying through the air – and shown himself to be a master storyteller.

In the end, *The Swing* did not make it into *Beauty and the Beast*, but its impact had not been forgotten. Over a decade later, Lisa Keene, who had worked on the earlier film, was inspired to use the painting for her concept studies for a new Disney production, *Tangled*. Three years later, the painting finally made it into a Disney movie, as part of the action in the picture gallery in the palace of Arendelle in *Frozen*.

Jean-Honoré Fragonard,
Les hasards heureux de l'escarpolette
(*The Swing*), *c.* 1767–8
Oil on canvas
THE WALLACE COLLECTION (P430)

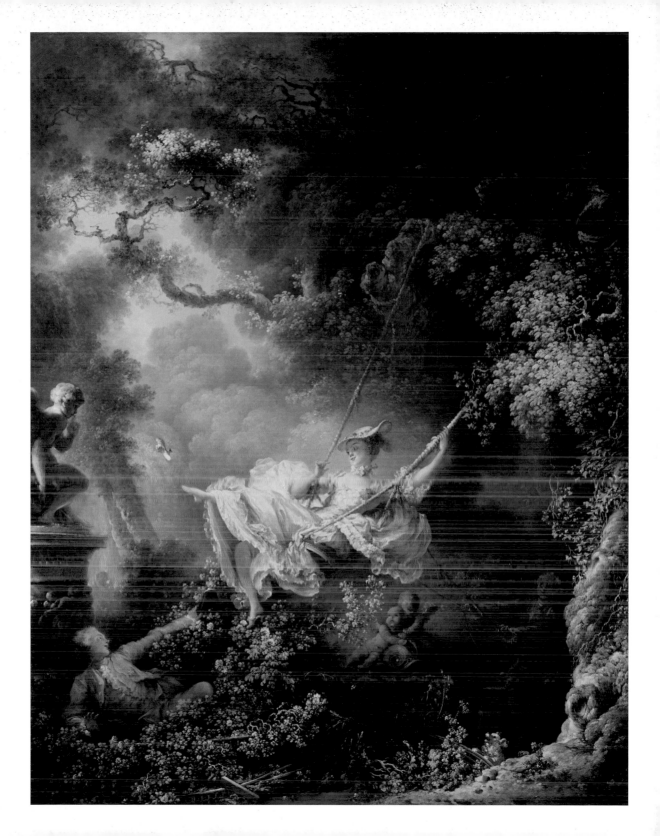

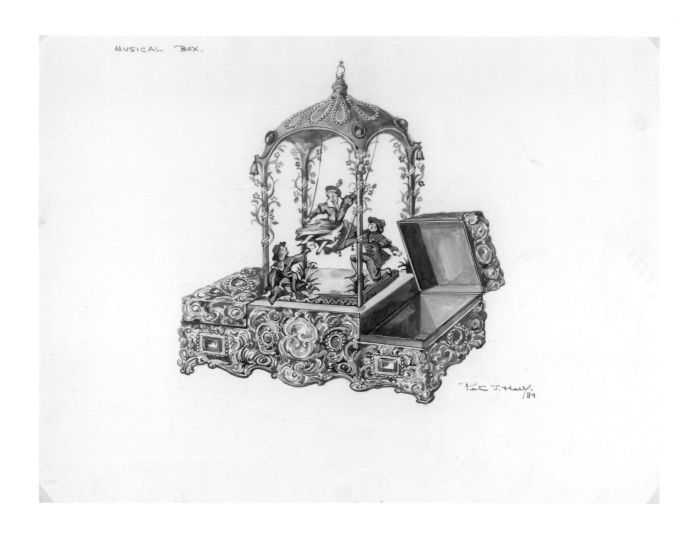

MUSICAL BOX.

Former Dallas Opera costume designer Peter J. Hall was commissioned to create some preliminary studies for *Beauty and the Beast*. He produced this rendering of a small, elaborate music box of a girl on a miniature swing for an early story reel of the opening scene. Encrusted with diamonds and precious stones, the golden music box was intended to be the only valuable item left in the family once Belle's rich merchant father had lost his entire fortune. Belle's willingness to sell it typified her selflessness and familial affection. However, the reel did not make it into production.

Peter J. Hall, The 'Swing' music box, concept art for *Beauty and the Beast* (1991), 1989
Watercolour on paper
WALT DISNEY ANIMATION RESEARCH LIBRARY

The artist Mel Shaw produced highly finished pastel renderings of scenes for the original opening sequence of *Beauty and the Beast*. One scene shows his imagining of Belle on a swing, pushed by her father, as inspired by Fragonard's famous painting, *The Swing*. The other is a second development of the 'Swing' music box.

Mel Shaw, concept art for the opening of *Beauty and the Beast* (1991), 1989
Pastel on board
WALT DISNEY ANIMATION RESEARCH LIBRARY

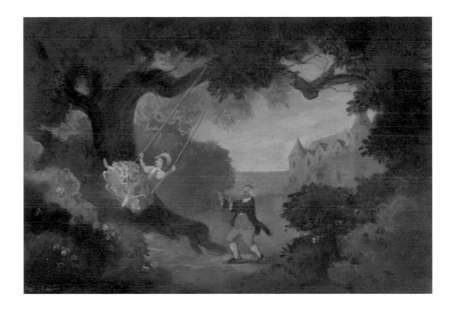

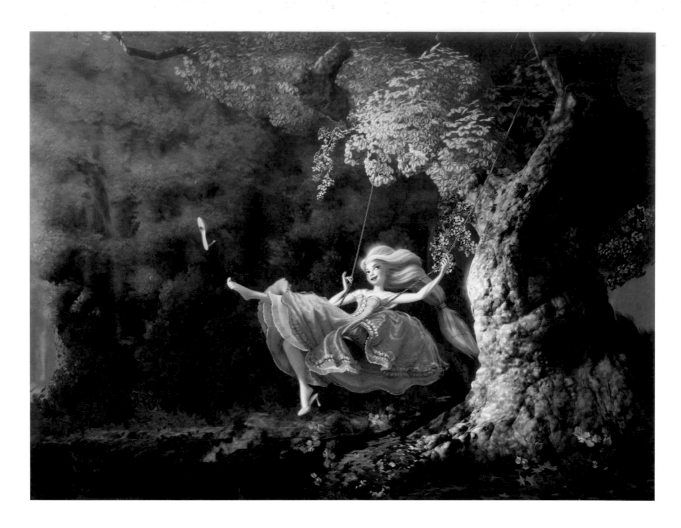

Although *The Swing* did not make it
into *Beauty and the Beast*, more than
a decade later Lisa Keene revisited
Fragonard as part of her concept studies
for *Tangled*. Glen Keane supervised
the creation of CGI test loops showing
the lead character riding a swing and
recalled how Lisa Keene had spent
months studying Fragonard's technique.

Lisa Keene and Kyle Strawitz, Rapunzel on
a swing, CGI test for *Tangled* (2010), 2008
Film frame
WALT DISNEY ANIMATION RESEARCH LIBRARY

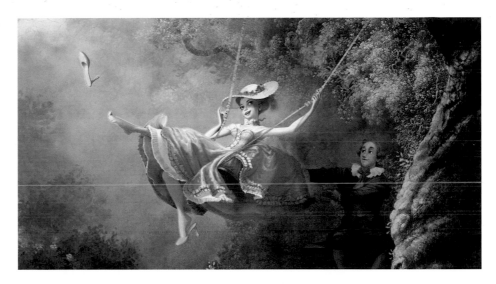

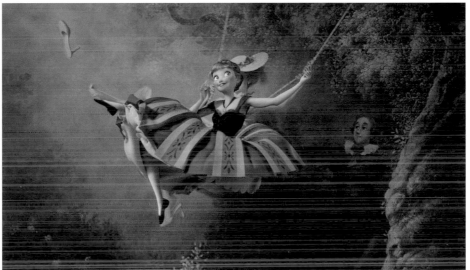

Though *The Swing* reference was once again omitted from *Tangled*, it finally made a cameo appearance in *Frozen*.

Walt Disney Animation Studios, cameo appearance of Fragonard's *The Swing* in *Frozen* (2013)
Detail of final frames

Eighteenth-Century Dress

Walt Disney Studios' artists explored the visual vocabulary of French eighteenth-century dress on numerous occasions. In addition to the fashions depicted in paintings, they had access to the reference library Walt Disney had helped to assemble, which contained several volumes illustrating eighteenth-century costume. However, the extravagance and pastel tones of male fashion in particular risked undermining the credibility and masculine appeal of a princely hero for a twentieth-century American audience. The intricacy of eighteenth-century court costume also proved too complicated for hand-drawn animation, which may explain why *The Emperor's New Clothes*, an unproduced short film after Hans Christian Andersen, for which James (Jim) Bodrero produced delightful story sketches in 1940, never saw the light of day. It also lay behind the decision to shift the fashions of both *Cinderella* and *Beauty and the Beast* into the nineteenth century, even though early designs had attempted to embrace the frills and lace of the Rococo.

For his chubby little emperor, Jim Bodrero took inspiration from Hyacinthe Rigaud's state portrait of Louis XIV, painted in 1701 as a parting gift for his grandson, the king of Spain. Ken Anderson also referenced Louis XIV's portrait in his depiction of a lion king for a proposed adaptation of the combined folk tales *Reynard the Fox* and *The Adventures of Chanticleer*, later repurposed as a proposal for Prince John in *Robin Hood* (1973).

(top) James (Jim) Bodrero, story sketch for *The Emperor's New Clothes* (unproduced), 1940s
Watercolour and coloured pencil on paper
WALT DISNEY ANIMATION RESEARCH LIBRARY

(bottom) Ken Anderson, concept art for *Robin Hood* (1973), repurposed from *Reynard the Fox* and *The Adventures of Chanticleer* (unproduced), 1960
Marker and photocopy on paper
WALT DISNEY ANIMATION RESEARCH LIBRARY

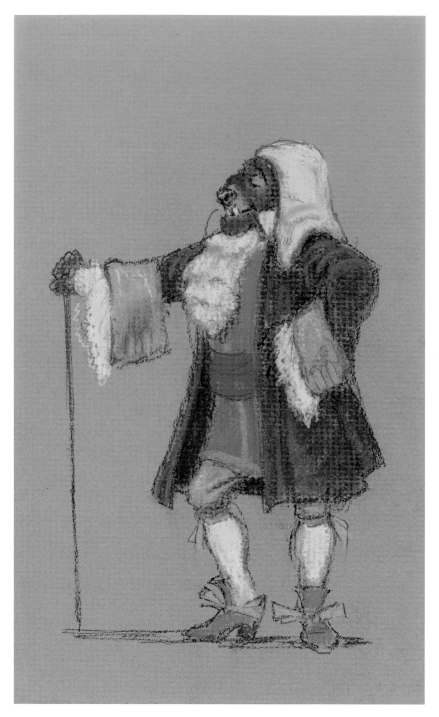

Thirty years after Anderson's royal lion, Mel Shaw's concept art for the Beast developed the reference to Louis XIV, adding the monarch's characteristic red heels. All three interpretations by different generations of animation artists attest to the timeless appeal of Rigaud's mighty composition. They also demonstrate how Disney's creative staff called on the work of their predecessors, with the Walt Disney Animation Research Library (which holds approximately 65 million physical artworks) acting as a magnificent resource.

Mel Shaw, The Beast, concept art for
Beauty and the Beast (1991), 1989
Pastel on paper
WALT DISNEY ANIMATION RESEARCH LIBRARY

Peter J. Hall's concept study retained eighteenth-century dress and experimented with mandrill features for the Beast.

(opposite) Peter J. Hall, The Beast, concept art for *Beauty and the Beast* (1991), *c.* 1989
Watercolour on paper
WALT DISNEY ANIMATION RESEARCH LIBRARY

BEAST.

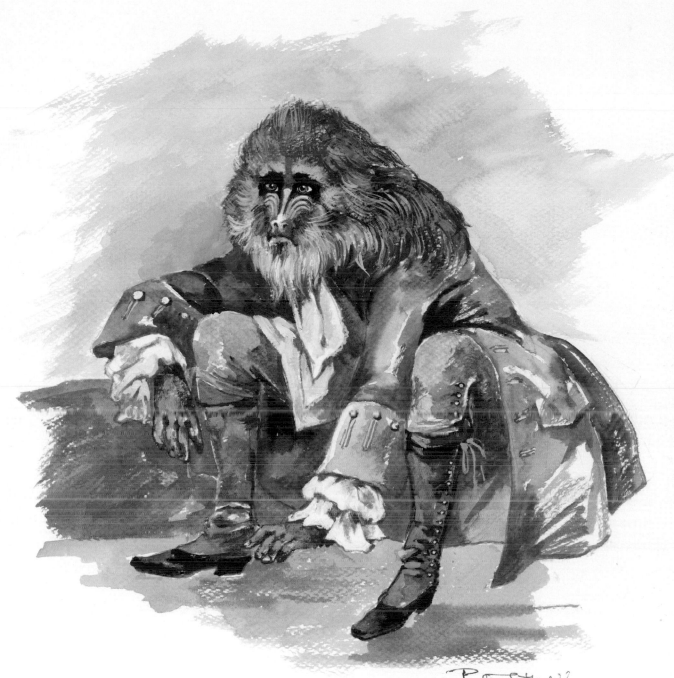

Peter S. Hall
'89

Jean Gillmore, whose sketches for Belle and Gaston parody the elaborate nature of eighteenth-century court dress, combed London's museums for inspiration.

(left) Jean Gillmore, Belle, concept art for *Beauty and the Beast* (1991) Photocopy and marker on paper
WALT DISNEY ANIMATION RESEARCH LIBRARY

(opposite) Jean Gillmore, Gaston, concept art for *Beauty and the Beast* (1991) Photocopy and marker on paper
WALT DISNEY ANIMATION RESEARCH LIBRARY

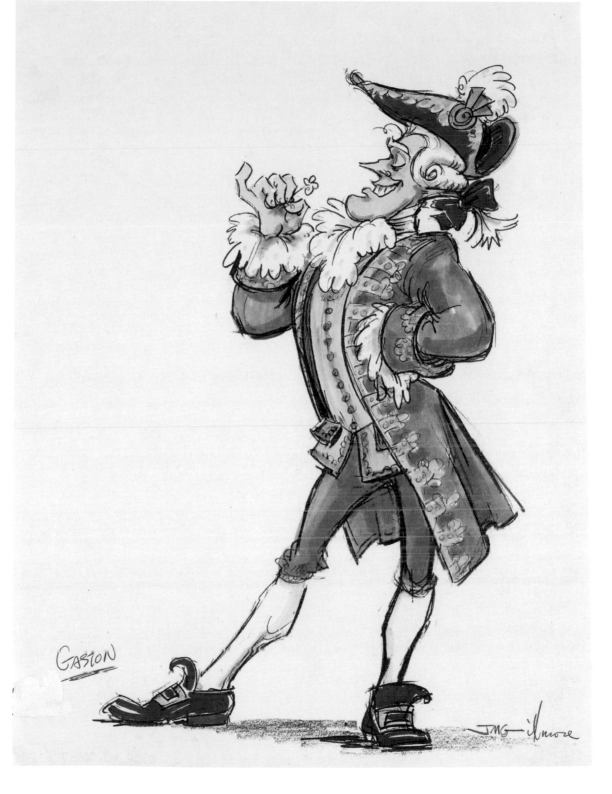

Animating the Inanimate

The human desire to anthropomorphise, or to animate inanimate objects, stretches back to prehistory. Walt Disney's early experiences with the *Silly Symphony* series tapped into this, with clocks, jugs, vases, pots and other objects coming to life. The phenomenal success of Mickey Mouse proved that attributing human characteristics and emotions to animals could be box-office gold, and subsequent generations of Disney artists have continued to delight and entertain with their inventive anthropomorphic characters.

Some of the most memorable scenes in *Beauty and the Beast*, beloved by both children and adults alike, are those in which the Beast's palace staff appear. Transformed by an enchantress into household objects, the characters of Cogsworth (the majordomo), Lumiere (the French maître d'hôtel) and Mrs Potts (the housekeeper) take the form of a mantel clock, a candlestick and a teapot. The talent of Joe Grant, Brian McEntee, Nik Ranieri, Will Finn, David Pruiksma and other studio artists was to help breathe life into these and other objects, simultaneously conveying both the physiognomy and the personality of the underlying humans in their sketches.

Eighteenth-century models informed many of their choices and it is not hard to see why: the Rococo was also about animating objects. Two hundred years before Walt Disney began to animate his cartoons, designers, goldsmiths and furniture-makers had also sought to breathe life into decorative art in a fusion of form and ornament that still surprises in its novelty. Striving to break out from the rigidity and norms of previous artistic traditions, they introduced asymmetry and flowing naturalistic forms to produce decorative art of outstanding originality and technical prowess.

The character of Mickey Mouse, created by Walt Disney and illustrated by animator Ub Iwerks, made his on-screen debut in 1928 and appeared in over 130 films. In *Thru the Mirror* (1936), the Studios' artists have exaggerated the physical aspects of the household furniture to give it human emotions.

Bob Wickersham, clean-up animation drawings from *Thru the Mirror* (1936)
Graphite and coloured pencil on paper

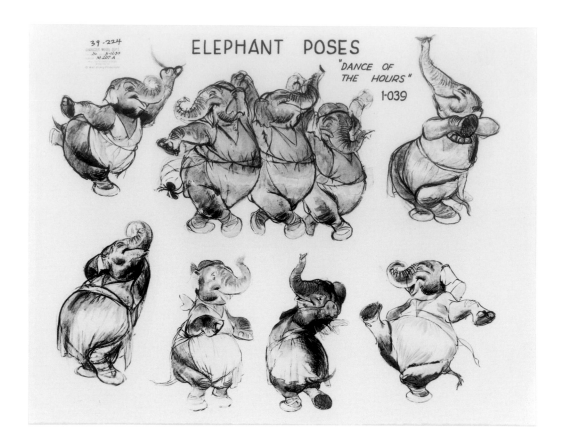

Fantasia, Disney's third animated feature film, comprised eight animated segments set to classical music. Here the artist explores the possibilities for the dancing elephants in a scene set to Ponchielli's *Dance of the Hours*.

Disney Studio Artist, dancing elephants, model sheet for *Fantasia* (1940), late 1930s
Photostat on paper
WALT DISNEY ANIMATION RESEARCH LIBRARY

Designed by Duplessis, a goldsmith by training, the plasticity and expression of this vase is testament to the skills of the craftspeople at Sèvres. Animated by the beautifully modelled heads, rounded body and flaring neck, which subtly echoes the tip of a trunk, the so-called elephant vase is a masterclass in expressive design. The delicate gilding of the faces – especially their wide smiles – leave us in no doubt that these are friendly elephants.

(opposite) Sèvres Porcelain Manufactory, design attributed to Jean-Claude Chambellan Duplessis, the Elder, vase with candleholders (vase '*à tête d'éléphant*'), one of a pair, 1757
Soft-paste porcelain, painted and gilded
THE WALLACE COLLECTION (C247)

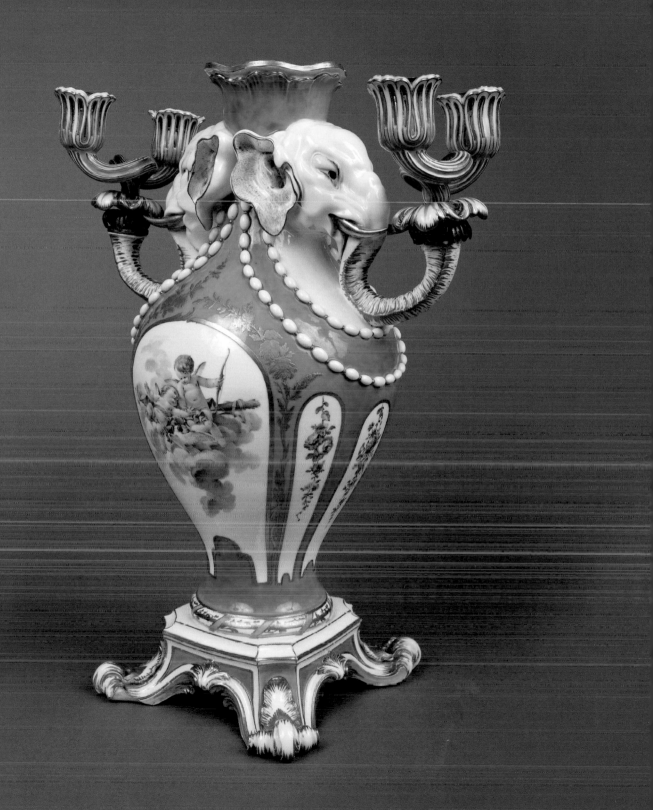

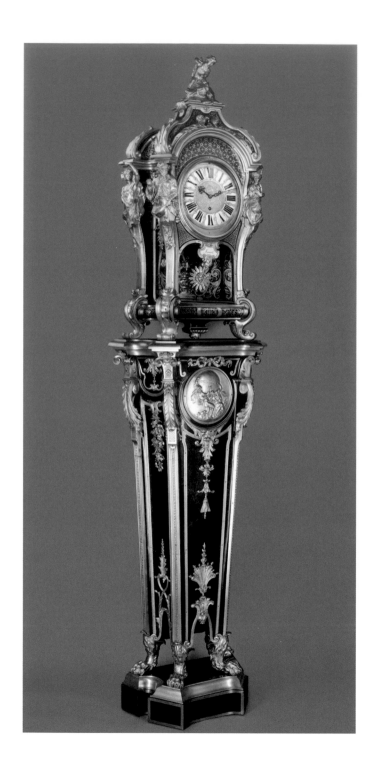

Peter J. Hall was an avid museum goer. He envisaged Cogsworth, the Beast's majordomo, in a black frock coat and breeches, liberally adorned with gold braid and epaulettes, resembling the black and gold of eighteenth-century Boulle furniture. The mottled effect of the scarlet waistcoat and stockings evokes the red-coloured turtleshell also found in Boulle marquetry. André-Charles Boulle perfected the art of metal marquetry, in which brass and turtleshell are combined in sheets of veneer. Known as Boulle marquetry, its magnificent shiny black and gold appearance gives an air of opulence, ideal for Cogsworth's court dress. For the Disney *Beauty and the Beast* live-action remake in 2017, the Wallace Collection Boulle clocks served as an important source of inspiration.

(opposite) Peter J. Hall, Cogsworth, concept art for *Beauty and the Beast* (1991), 1989
Marker and gouache on paper
WALT DISNEY ANIMATION RESEARCH LIBRARY

(left) Attributed to André-Charles Boulle (cabinetmaker), Louis Mÿnuël (movement maker), clock with pedestal, *c.* 1720–25
Oak, turtleshell, *première-partie* Boulle marquetry of brass and turtleshell, gilt bronze, glass, enamel, brass and ebony
THE WALLACE COLLECTION (F42)

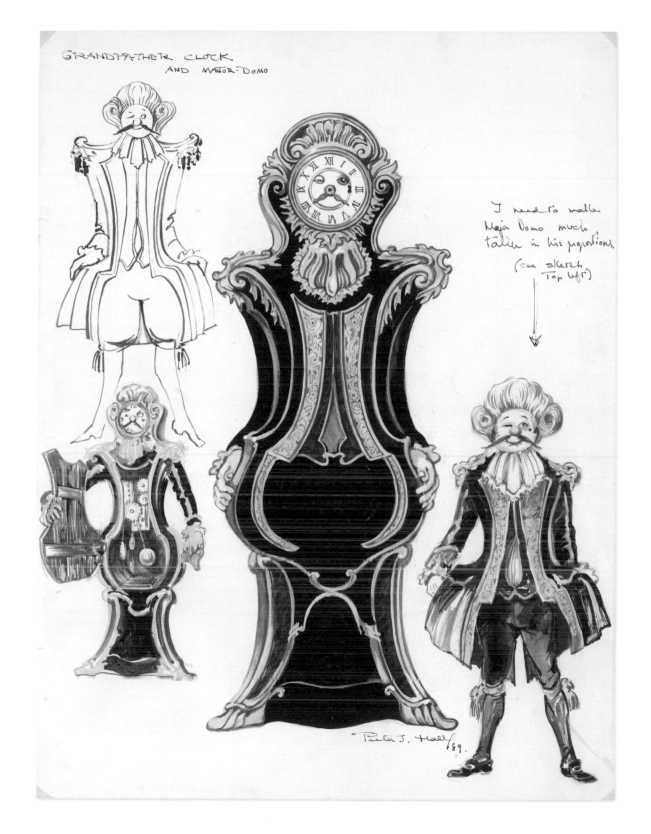

GRANDFATHER CLOCK
AND MAJOR-DOMO

I need to make
Maja Domo much
taller in his proportions.
(see sketch
Top left)

Peter J. Hall /89.

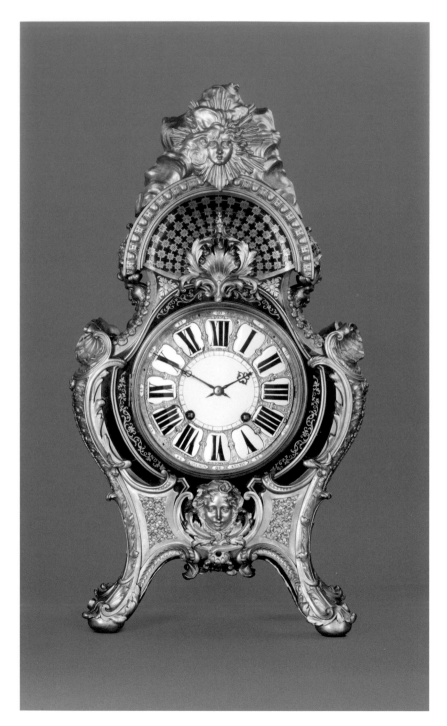

When Brian McEntee took over the artistic direction of *Beauty and the Beast*, he suggested that Cogsworth be changed from a longcase to a mantel clock, so as to improve his capacity to interact with the other cast members – Mrs Potts and Lumiere. Model sheets were designed to assist the large team of animators to understand the various angles and emotional responses of each character.

(opposite) Brian McEntee, Cogsworth, concept art for *Beauty and the Beast* (1991), *c.* 1990
Marker and photocopy on paper
WALT DISNEY ANIMATION RESEARCH LIBRARY

(opposite below) Disney Studio Artist, Cogsworth, model sheet for *Beauty and the Beast* (1991), 1990
Photocopy, ink, graphite and collage elements on paper
WALT DISNEY ANIMATION RESEARCH LIBRARY

Jacques Gouchon (movement maker), bracket clock, *c.* 1730
Oak, *première-partie* Boulle marquetry of brass and turtleshell, gilt bronze, brass, enamel and glass
THE WALLACE COLLECTION (F409)

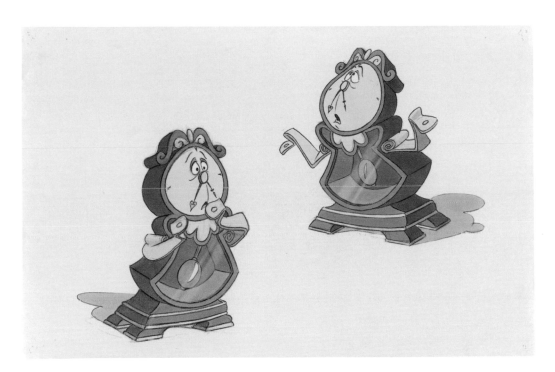

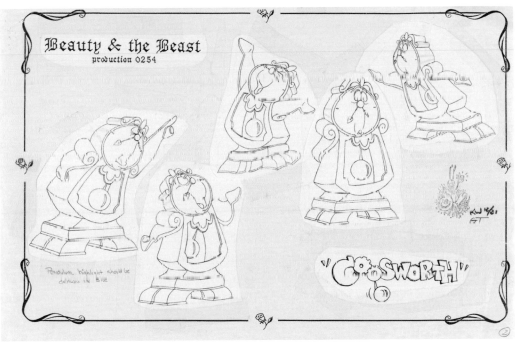

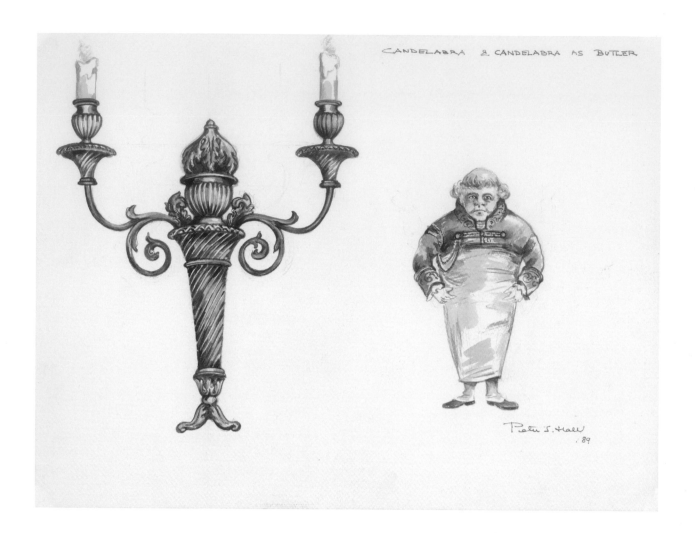

CANDELABRA & CANDELABRA AS BUTLER

Peter J. Hall
. 89

As with his designs for Cogsworth, Peter J. Hall's preliminary workings of Lumiere have made both the form and material of the candelabrum expressive of the stance and dress of the human embodied in it.

Peter J. Hall, Lumiere, concept art for *Beauty and the Beast* (1991), 1989
Gouache, marker and ink on paper
WALT DISNEY ANIMATION RESEARCH LIBRARY

Eighteenth-century candlesticks were often made from gilt bronze, which gave added richness to an interior and allowed the light to be reflected, whilst providing a warm flickering effect. The flowing candle arms and paw feet lend further animation to this model.

(opposite) Pair of candelabra, *c.* 1775, France
Gilt bronze
THE WALLACE COLLECTION (F126, F127)

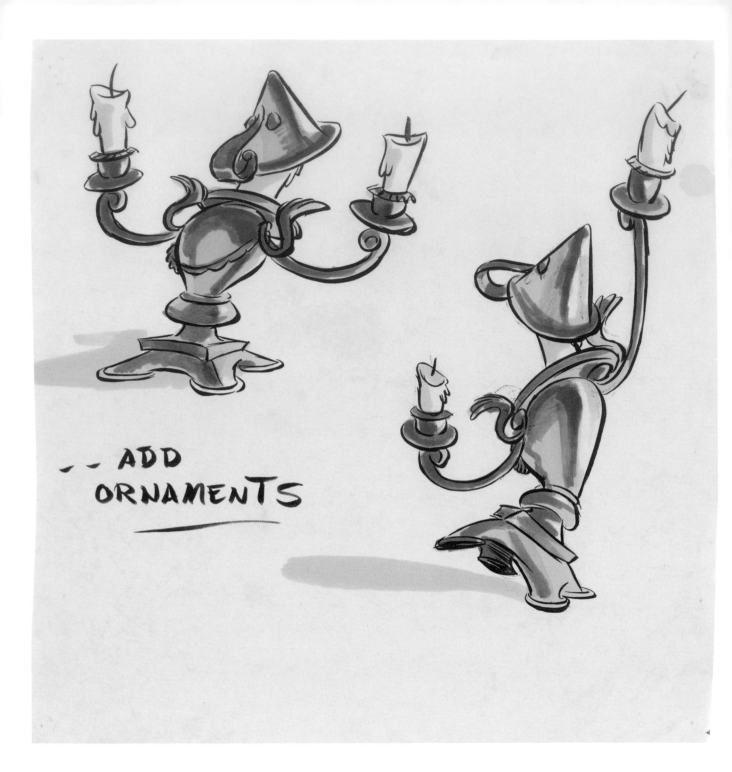

-- ADD
ORNAMENTS

This early sketch for Lumiere, the flamboyant counterpart to the tightly wound Cogsworth, shows him with something of a shifty demeanour, his body tinted blue rather than yellow, suggesting that he was initially meant to have been made of silver instead of gilt bronze.

Kevin Lima, Lumiere, concept art for *Beauty and the Beast* (1991), *c.* 1990
Photocopy, gouache and marker on paper
WALT DISNEY ANIMATION RESEARCH LIBRARY

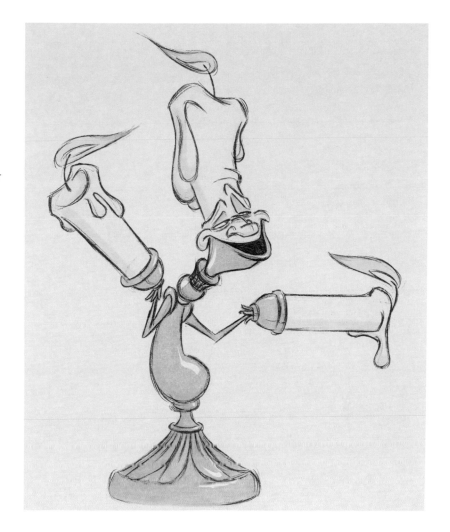

(opposite) Disney Studio Artist, Lumiere, concept art for *Beauty and the Beast* (1991) *c.* 1990
Photocopy, marker and ink on paper
WALT DISNEY ANIMATION RESEARCH LIBRARY

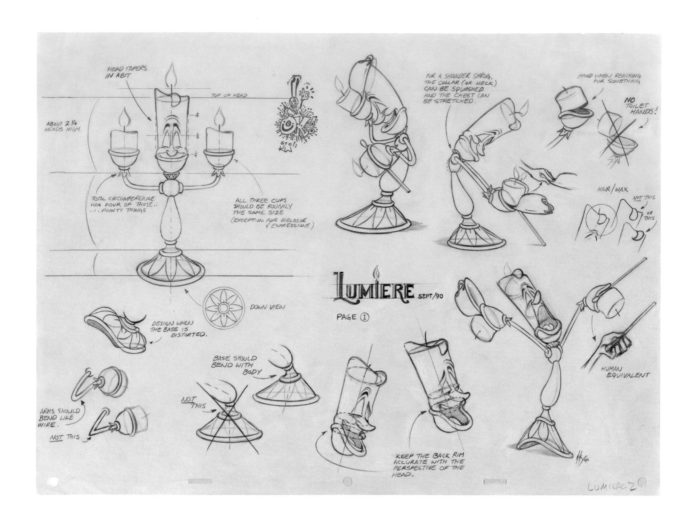

Disney Studio Artist, Lumiere, model
sheet for *Beauty and the Beast* (1991)
Coloured pencil, graphite and ink
on paper

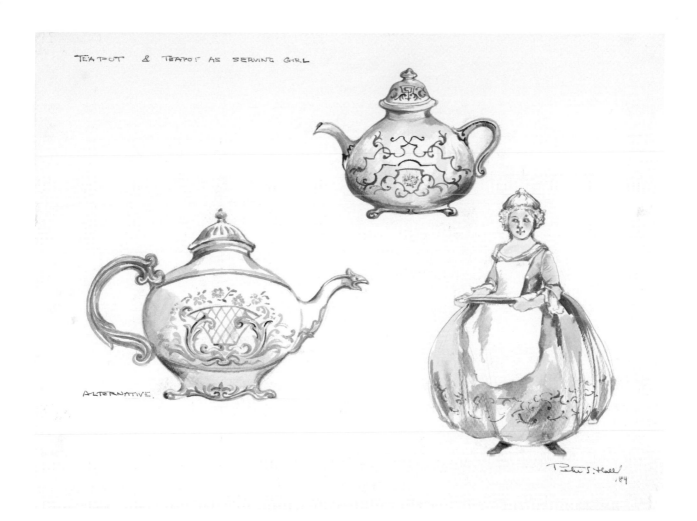

TEAPOT & TEAPOT AS SERVING GIRL

ALTERNATIVE.

Mrs Potts is the third of the main
supporting cast of anthropomorphic
objects inhabiting the enchanted castle.
Through warmth and kindness, she hopes
to counterbalance the Beast's behaviour.
Peter J. Hall appears to have chosen
two of the earliest models of Meissen
porcelain teapots for his inspiration.

Peter J. Hall, Mrs Potts, concept art for
Beauty and the Beast (1991), c. 1989
Watercolour and ink on paper
WALT DISNEY ANIMATION RESEARCH LIBRARY

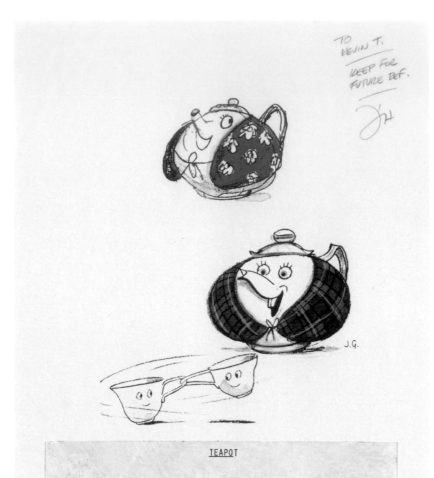

TO
KEVIN T.
KEEP FOR
FUTURE REF.

J.G.

TEAPOT

LADY TEASDALE IN HER PLAID COZY, SURROUNDED BY HER CLATTERING
CUPS AND SAUCERS -- CHARACTER NOTE: LIKE A MOTHER HEN "EVERY-
THING CAN BE SETTLED, NO MATTER HOW BAD, "BY HAVING A NICE
CUP OF TEA!"

Brian McEntee, art director for *Beauty and the Beast*, likened Mrs Potts's disposition to that of a reassuring English grandmother type, a gentle feminine force balancing the two constantly competing male egos of the charismatic Lumiere and the anxious and exacting Cogsworth.

(left) Joe Grant, Mrs Potts, concept art for *Beauty and the Beast* (1991)
Photocopy, marker, ink and graphite on paper
WALT DISNEY ANIMATION RESEARCH LIBRARY

(opposite) Chris Sanders, Mrs Potts, concept art for *Beauty and the Beast* (1991), *c.* 1989
Pastel on paper, adhered to board
WALT DISNEY ANIMATION RESEARCH LIBRARY

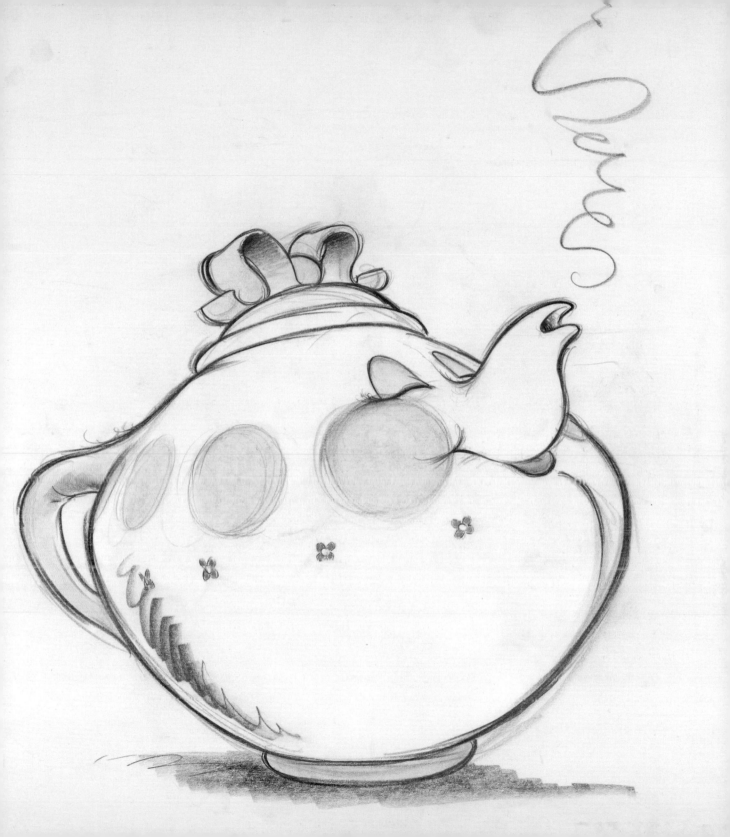

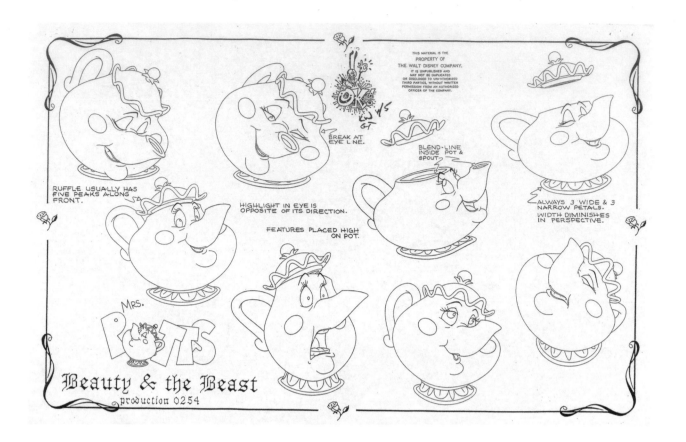

In *Beauty and the Beast* Disney Legend Dame Angela Lansbury lent her voice to the jovial and affectionate Mrs Potts, for which David Pruiksma acted as supervising animator. He closely observed Lansbury's mannerisms, which involved frequent and lively head tilting, and successfully converted them into hand-drawn animation.

Disney Studio Artist, Mrs Potts, model sheet for *Beauty and the Beast* (1991) Photocopy on paper

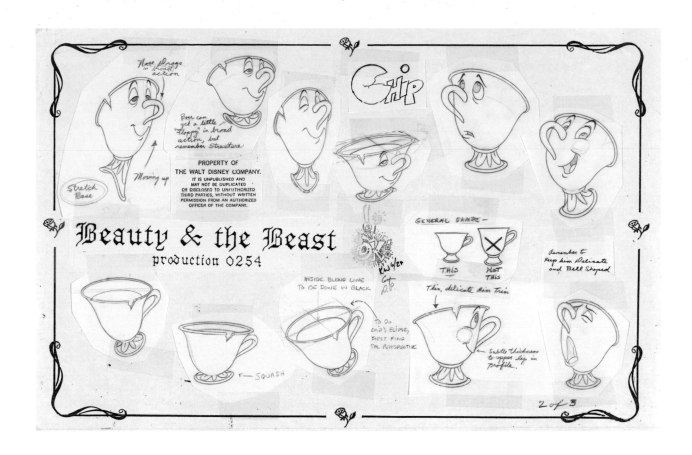

Mrs Potts's young son, Chip, is forever
getting into trouble. As is often the case
with Disney films, the characters' names
are laden with meaning. Once again,
with quick, simple strokes, here the artist
has captured the 'naughty schoolboy'
character, manifested in a simple object.

Disney Studio Artist, Chip, model sheet
for *Beauty and the Beast* (1991)
Coloured pencil, graphite, ink and
photocopy on paper
WALT DISNEY ANIMATION RESEARCH LIBRARY

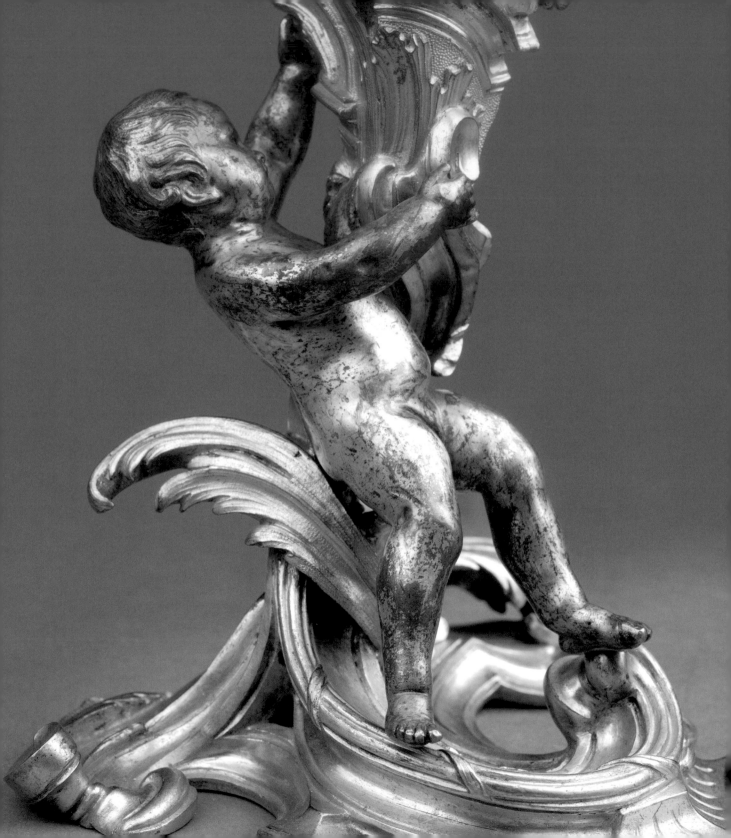

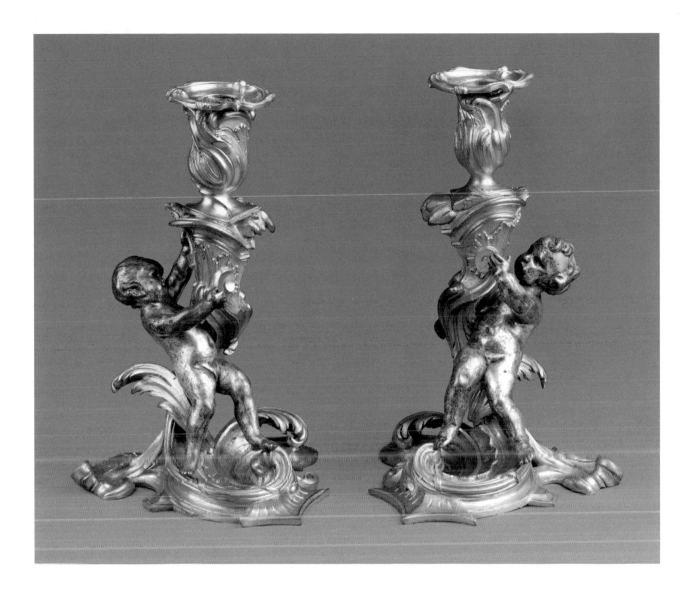

These candlesticks exemplify the twisting, turning, scrolling designs that characterised work by Juste-Aurèle Meissonnier. The eye is drawn across and around the object, unable to settle, in a manner that was much praised by contemporary supporters of the 'modern taste'. A similar design published by Meissonnier was depicted in three different engravings, since no two views of the object are the same.

Design attributed to Juste Aurèle Meissonnier, pair of candlesticks, 1745–9
Gilt bronze and silvered bronze
THE WALLACE COLLECTION (F78, F79)

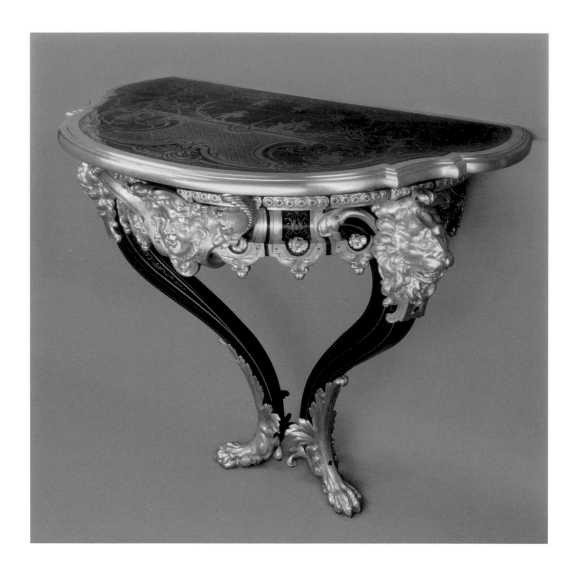

André-Charles Boulle pushed the three-dimensionality of his works beyond the bounds of traditional cabinetmaking. Gilt-bronze mounts included animal motifs, such as the expressively modelled lions' heads and shaggy paw feet of this table, with its animated double-curved legs of a type never seen before.

Attributed to André-Charles Boulle, console table, *c.* 1705
Oak, walnut, ebony, gilt bronze and *première-partie* Boulle marquetry of brass and turtleshell
THE WALLACE COLLECTION (F56)

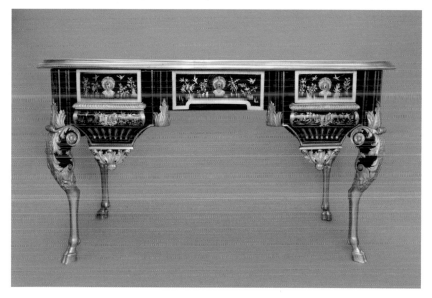

Like Disney animation artists, eighteenth-century marquetry cutters also used their medium to tell a story. Here the hunter Actaeon is shown surprising the goddess Diana while she bathes in a fountain. He is turned into a stag by the enraged goddess, who splashes him with water. Inventively, the craftsman has used mother-of-pearl to give the water a luminous effect. The narrative effect of the marquetry surface is extended to the seemingly bizarre form of the table, with its gilt-bronze zoomorphic legs. Not just Actaeon, it seems, was transformed into a stag

Attributed to Bernard I van Risenburgh, knee-hole writing table, *c.* 1715
Oak, *première-partie* Boulle marquetry of brass, turtleshell and mother-of-pearl, walnut, gilt bronze and brass
THE WALLACE COLLECTION (F58)

Designed by Duplessis, who trained as a goldsmith and bronze founder, the fluid, curved lines of this vase suggests that he was used to working with materials that could pour. The gilding on the edges of the handles and neck, and the turquoise ground colour, recall splashing water. The organic shape would have presented considerable difficulties in firing, the results of which are still visible in the slightly imperfect outline.

Vincennes Porcelain Manufactory (later Sèvres), design attributed to Jean-Claude Chambellan Duplessis, the Elder, one of a pair of 'ear' vases (vase '*à oreilles*'), 1756
Soft-paste porcelain, painted and gilded
THE WALLACE COLLECTION (C241)

One of only ten surviving ship vases made at Sèvres, the execution of Duplessis's design demanded all the technical prowess of which the manufactory was capable. The vase's animation is enhanced by the decoration: the pennant flutters, the rigging seemingly shudders from the impact of the waves crashing on the base, and the fantastic marine beasts face into the wind, their moustaches streaming either side.

(opposite) Sèvres Porcelain Manufactory, design attributed to Jean-Claude Chambellan Duplessis, the Elder, potpourri vase and cover (vase '*pot-pourri à vaisseau*' or '*pot-pourri en navire*'), *c*. 1761
Soft-paste porcelain, painted and gilded
THE WALLACE COLLECTION (C256)

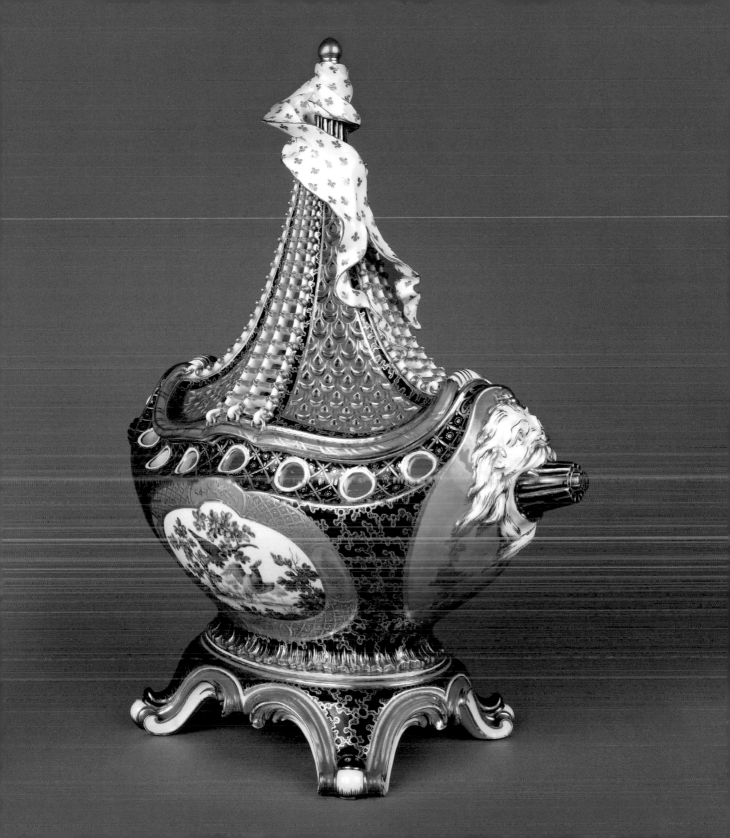

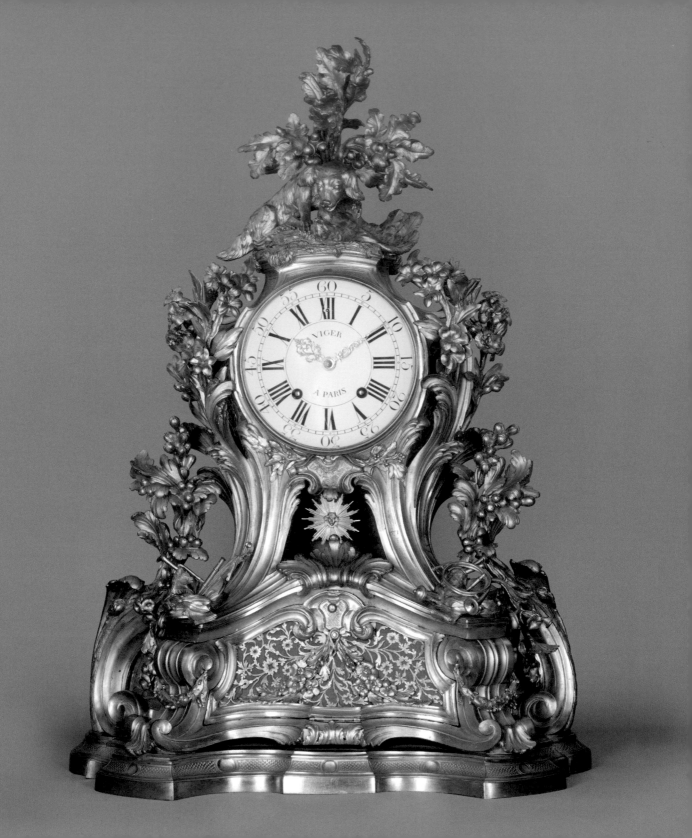

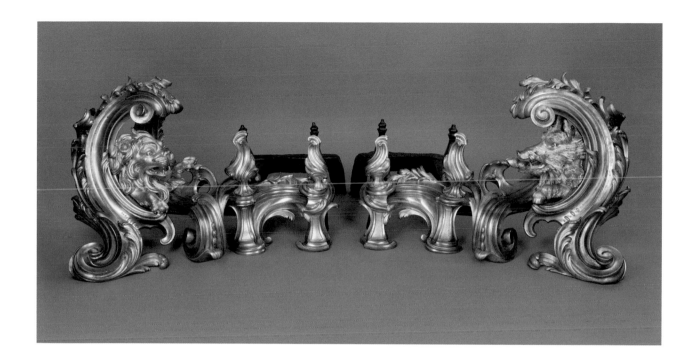

Despite his commitment to Sèvres, Duplessis continued to design works in gilt bronze. This clock case is related to one of his porcelain models. The organic 'legs' appear to explode from the base, pushing the clock face ever more upwards, drawing our eyes to tell the time. Gilt-bronze flowers, leaves and acorns conjure up the autumn hunting season that played such a large part in the life of the court of Louis XV. On the hour, every hour, the clock plays one of 13 tunes.

(opposite) Attributed to Jean-Claude Chambellan Duplessis, the Elder (goldsmith and designer), François-René Morlay (caster and chaser), François Viger (movement maker), Claude Richard (spring maker), clock, c. 1762
Gilt bronze, silk, glass, brass, enamel and steel
THE WALLACE COLLECTION (F97)

Jacques Caffieri produced powerfully expressive forms that displayed a mastery rarely matched in gilt bronze. Firedogs, with supports to hold the logs, were placed in front of a chimney, allowing the flickering firelight to bounce off the undulating surfaces. On either side, the head of a lion and a boar burst explosively out of flaming rococo ornament, their bodies seemingly in motion.

(above) Attributed to Jacques Caffieri, probably assisted by Philippe Caffieri, pair of firedogs, c. 1752
Gilt bronze, wrought and cast iron and steel bolts
THE WALLACE COLLECTION (F107, F108)

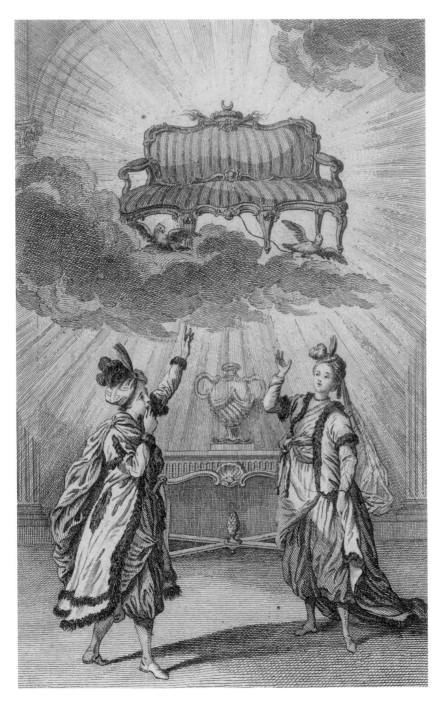

Beauty and the Beast is characteristic of so-called 'transformational literature': novels which were written for adults in which objects and people fall under magic spells, transforming them into other beings from which they could only escape through the power of good deeds, true love, or the expression of moral integrity. Adopted by authors as a means of inverting contemporary values, Claude Prosper Jolyot de Crébillon, a close associate of Villeneuve, published *The Sofa* in 1742. His hero's soul is condemned to inhabit a succession of sofas until he witnesses a genuine declaration of true love on his sofa-body. A satire on the French court and society manners, it was also a parody of modern taste: coming as it did from the Ottoman world, this relatively new form of seat furniture, with its connotations of luxury and intimacy, was to be found in all the most fashionable interiors.

Frontispiece to *Le Sopha: conte moral* (*The Sofa: A Moral Tale*) by Claude Prosper Jolyot de Crébillon, 1774 (first edition 1742)

Canapé exécuté pour M.^r le Comte de Bielenski Grand M.^{al} de la Couronne de Pologne, en 1735.
A Paris chés Huquier ruë S.^t Jacque au coin de celle des Mathurins CPR.

Juste-Aurèle Meissonnier's designs pushed the boundaries of technical possibilities, exploding traditional forms and abandoning straight lines. This print records his design for a sofa, its outline echoing the dramatic wall panelling behind it. The sofa was designed for the Polish Count Franciszek Bieliński and is one of many examples of Meissonnier's work for an elite international clientele, which helped define a taste for the rococo style across Europe.

Juste-Aurèle Meissonnier (goldsmith and designer), Gabriel Huquier (engraver), *Canapé exécuté pour Mr le Comte de Bielinski*, from *Oeuvre de Juste-Aurèle Meissonnier*, c. 1742–8
Etching and engraving
THE METROPOLITAN MUSEUM OF ART, NEW YORK
(18.62.5(51))

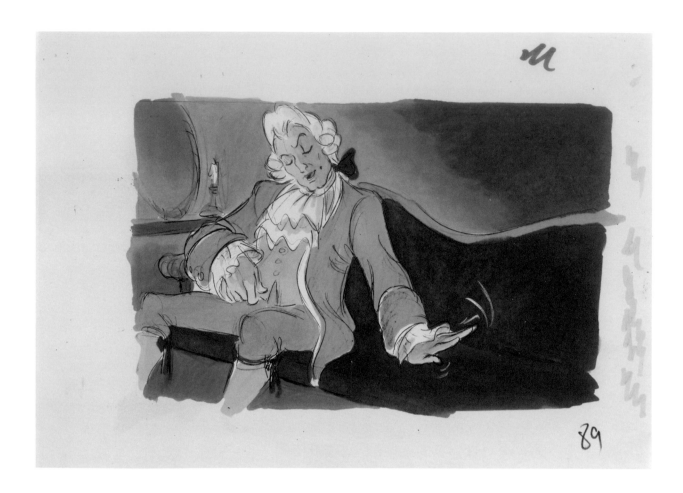

The opportunities offered for flirtation were one of the reasons for the sofa's immediate success when it was introduced in Europe from the Ottoman Empire at the end of the seventeenth century. Eighteenth-century authors and artists made use of the possibilities it presented for moving along a narrative. In developing the villainous Gaston, the Disney artists working on *Beauty and the Beast* also explored its potential.

Disney Studio Artist, Gaston invites Belle to sit beside him, story sketch for *Beauty and the Beast* (1991), 1989
Marker and photocopy on paper
WALT DISNEY ANIMATION RESEARCH LIBRARY

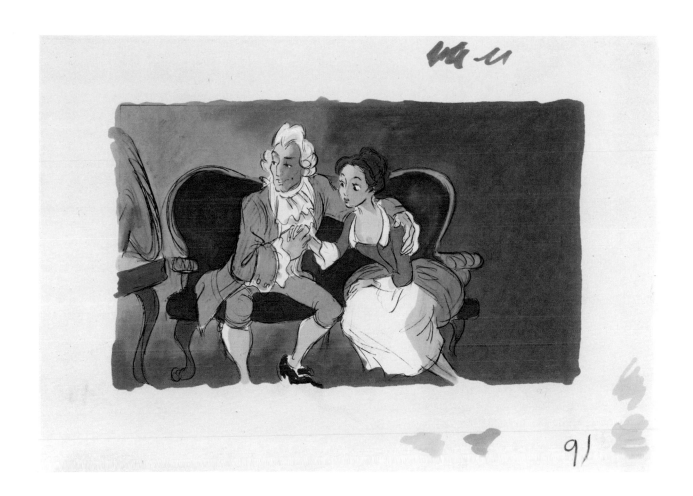

Disney Studio Artist, Gaston and
a reluctant Belle seated on a sofa,
story sketch for *Beauty and the Beast*
(1991), 1989
Marker and photocopy on paper
WALT DISNEY ANIMATION RESEARCH LIBRARY

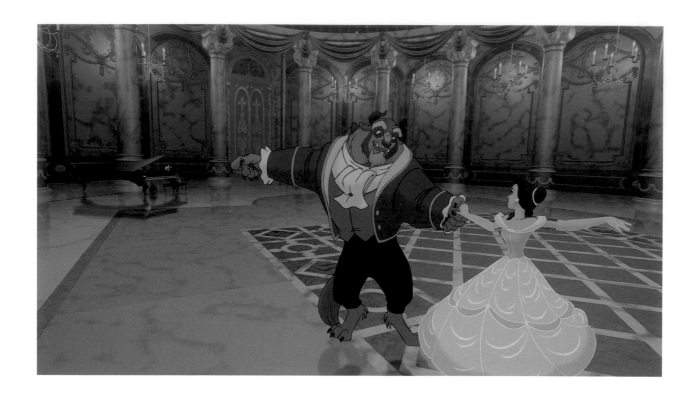

The narrative crescendo of *Beauty and the Beast* leads us to the most spectacular room in the castle and to a magnificent sequence: Belle and the Beast waltzing through a three-dimensional ballroom. The scene was a cutting-edge cinematic sequence involving the latest CGI technology. It became a signature moment from the film.

Disney Studio Artists, *Beauty and the Beast* (ballroom scene), 1991
Final frame

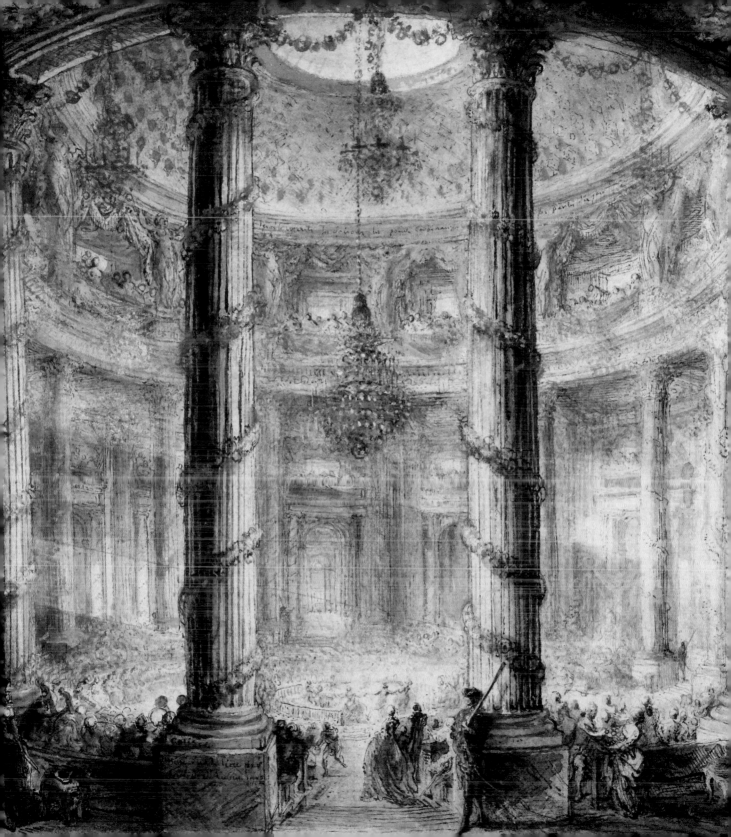

Further Reading

Jean-François de Bastide, *La Petite Maison* (*The Little House: An Architectural Seduction*), translation and introduction by Rodolphe el-Khoury (New York: Princeton Architectural Press, 1996)

Wolf Burchard, *Inspiring Walt Disney: The Animation of French Decorative Arts* (New York: The Metropolitan Museum of Art/Yale University Press, 2021)

Sarah D. Coffin et al., *Rococo: The Continuing Curve, 1730–2008*, exh. cat. (New York: Cooper-Hewitt National Design Museum, 2008)

Claude Prosper Jolyot de Crébillon, *Le Sopha: conte moral* (Paris, 1742)

Stephen Duffy and Jo Hedley, *The Wallace Collection's Pictures: A Complete Catalogue* (London: Unicorn Press, 2004)

Peter Fuhring, *Juste-Aurèle Meissonnier: Un génie du rococo, 1695–1750* (2 vols), (Turin: Umberto Allemandi, 1999)

Neil Gabler, *Walt Disney: The Triumph of the American Imagination* (New York: Random House, 2006)

Didier Ghez, *Disney's Grand Tour: Walt and Roy's European Vacation, Summer 1935* (Orlando: Theme Park Press, 2013)

Peter Hughes, *French Eighteenth-Century Clocks and Barometers in the Wallace Collection* (London: Trustees of the Wallace Collection, 1994)

Peter Hughes, The Wallace Collection Catalogue of Furniture (3 vols), (London: Trustees of the Wallace Collection, 1996)

Mindy Johnson, *Ink & Paint: The Women of Walt Disney's Animation* (Glendale: Disney Editions, 2017)

Rosalind Savill, *The Wallace Collection Catalogue of Sèvres Porcelain* (3 vols) (London: Trustees of the Wallace Collection, 1988)

Rosalind Savill, *Everyday Rococo: Madame de Pompadour and Sèvres Porcelain* (2 vols) (London: Unicorn Press, 2021)

Bob Thomas, *Walt Disney: An American Original* (Glendale: Disney Editions, 1994)

Charles Truman, *The Wallace Collection Catalogue of Gold Boxes* (London: Trustees of the Wallace Collection, 2013)

Gabrielle-Suzanne Barbot de Villeneuve, *Beauty and the Beast: The Original Story*. Edited and translated by Aurora Wolfgang (Toronto: Iter Press, 2020)

Picture Credits

Full page images

Endpapers (detail, yellow tint) Juste-Aurèle Meissonnier, Elevation of the wall of the salon of Princess Czartorinska, plate 85 in *Oeuvres de Juste-Aurèle Meissonnier* (*Works by Juste-Aurèle Meissonnier*), 1748, engraved by Pierre Edme Babel. Gift of Eleanor and Sarah Hewitt, courtesy of Cooper Hewitt, Smithsonian Design Museum

Frontispiece (p. ii) (detail) Mary Blair, Cinderella looking into a mirror, concept art for *Cinderella* (1950), 1940s (see p. 35). © Disney

p. iv (detail) Jean Ducrollay, snuffbox, *c.* 1744 (G4) (see p. 15, fig. 20). © Wallace Collection, London

p. vi (detail) Peter J. Hall, The 'Swing' music box, concept art for *Beauty and the Beast* (1991), 1989 (see p. 56). © Disney

p. ix Walt Disney Animation Studios, cameo appearance of Fragonard's *The Swing* in *Frozen* (2013) (see p. 59). © 2013 Disney

p. x (detail) Kevin Lima, Lumiere, concept art for *Beauty and the Beast* (1991), *c.* 1990 (see p. 77). © Disney

p. 17 (detail) Attributed to Jacques Caffieri, fire-dog, *c.* 1752 (F108) (see p. 91) © Wallace Collection, London

p. 18 (detail) Sevres Porcelain Manufactory, one of a pair of vases with candle holders (vase '*à tête d'éléphant*'), *c.* 1758 (C247) (see p. 69). © Wallace Collection, London

p. 97 (detail) Gabriel Jacques de Saint-Aubin, *A Fête in the Colisée*, 1772 (P790) (see p. 53). © Wallace Collection, London

Figures

Fig. 2 Sèvres Porcelain Manufactory, *The Magic Lantern, c.* 1760. Modelled by Étienne-Maurice Falconet, based on a design by François Boucher. Soft-paste biscuit porcelain. © Michele Beiny Inc

Fig. 3 © Disney

Fig. 4 Höchst Manufactory, Johann Friedrich Lück, dancer, *c.* 1758. Based on an engraving by Nicolas de Larmessin III of a portrait of Marie Sallé by Nicolas Lancret. Hard-paste porcelain. The Metropolitan Museum of Art, New York, Gift of Irwin Untermyer, 1964 (64.101.287). Image © The Metropolitan Museum of Art, photo by Richard Lee

Figs 5–9 © Disney

Fig. 10 Jean-Baptiste I Tilliard or possibly Jean-Baptiste II Tilliard, sofa (*ottomane veilleuse*), *c.* 1750–60, carved and gilded beechwood, upholstered in modern red velours de Gênes. The Metropolitan Museum of Art, New York, The Jack and Belle Linsky Collection, 1982 (1982.60.72). Image © Metropolitan Museum of Art

Fig. 11 © Disney

Fig. 12 © Wallace Collection, London

Fig. 13 Sèvres Porcelain Manufactory, modelled by Étienne-Maurice Falconet, *L'amour Falconet* and '*piédestal de l'amour*' (Cupid on a Pedestal), *c.* 1761–3, soft-paste biscuit porcelain (C492). © The Wallace Collection, London

Figs 14–17 © Disney

Fig. 18 © The Wallace Collection, London

Fig. 19 © The Wallace Collection, London

Fig. 20 Jean Ducrollay, snuffbox, *c.* 1744, gold and enamel (G4). © Wallace Collection, London

Fig. 21 © Wallace Collection, London

Selected Works

© Bibliothéque nationale de France: p. 21

Courtesy of Walt Disney Imagineering Collection: p. 22

© The Victoria & Albert Museum, London. Given by Lady Charlotte Schreiber: p. 25

© 1931 Disney: p. 27

© Disney: pp. 28 (top and bottom), 29 (top and bottom), 30 (top), 33–44, 45 (top and bottom), 46, 49, 50 (top and bottom), 51, 52, 56, 57 (top and bottom), 61 (top and bottom), 62–5, 67, 68, 71, 73, 74, 76–83, 94, 95.

© 1934 Disney: p. 30 (bottom)

Image © The Metropolitan Museum of Art: pp. 31, 48, 93

Courtesy of the Huntington Art Museum, San Marino, California: pp. 47

© Wallace Collection, London: pp. 53, 55, 69, 70, 72, 75, 84–91, 97

© 2010 Disney: p. 58

© 2013 Disney: p. 59 (top and bottom)

Image © The Metropolitan Museum of Art, photo by Mark Morosse: p. 92

© 1991 Disney: p. 96

Photography of works in The Wallace Collection are by Cassandra Parsons, Photographer and Digital Assets Manager, The Wallace Collection.

Index

Page numbers in *italics* refer to illustrations.

Adventures of Chanticleer, The
(unproduced) *61*, *61*
Anderson, Ken, 61, *61*, 62
animation, 8–16, *11*, 66; anthropomorphic
characters, 66, 79; *Beauty and the
Beast*, 1, *11*, 13, 66; *Cinderella*, 6–7,
8–9; Disney, Walt, 3–4, *11*, 28; Disney
artists, *11*; Disney Studios, 5; hand-
drawn animation, 1, 16, 19, 26, 28, 32,
40, 54, 60, 82; multiplane camera, 6,
11; porcelain, furniture, clocks, 4–5, *11*,
26, 66; Rococo and, 1–2, 6, 66; *Silly
Symphony* series, 26; spatial dimension, 6,
11; story sketches, 28, *28–30*, 60

Bacher, Hans, 8, *10*, 45, *48*, *49–50*, *51*
Bastide, Jean-François de: *La Petite Maison*,
10
Beaumont, Jeanne-Marie Leprince de, 9
Beauty and the Beast (1991), 1, 10, 19, 54,
92; animation, 1, *11*, 13, 66; architecture,
7–8; ballroom, 7–8, *8*, *52*, *52*, 96, *96*;
Beast, 10, 62, *62–3*, 96; Belle, 10, *64*,
64, *95*, 96; castle, 8, 10, *11*, 42, 45–6,
45–6, *49–51*, *51*; Chip, 12, 13, *83*, *83*;
Cogsworth, *12*, 13, *13*, 66, *70*, 71–2, *73*,
80; dress, 60, 62, *62–3*, *64*, *64–5*, 71;
Gaston, 9, 10, 64, *65*, *94*, *94–5*; Lumiere,
x, 13, 66, 74, *74*, 76, 77, *77–8*, 80; Mrs
Potts, *12*, 13, 66, 79–80, *79–82*, 82; sofa,
9, 10, *94*, *94–5*; *The Swing*, 54, 57, *57*
Beauty and the Beast (fairy tale), 3, 20;
Beaumont, Jeanne-Marie Leprince de, 9;
Villeneuve, Gabrielle-Suzanne Barbot de,
9–10, 54
Beckford, William, 7
Blair, Mary, 6, 34, 42; *Cinderella*, *ii*, *5–7*, *6*,
7, *34*, *34–7*, *44*, 45
Bodrero, James (Jim), 60, *61*, *61*
Boucher, François, 3, 4, *25*
Boulle, André-Charles, 13; clock with
pedestal (design attributed), *70*; console
table (design attributed), *14*, 86, *86*;

marquetry, *13–14*, 70, 72, 86, *87*

Caffieri, Jacques, 2, 16; firedogs (design
attributed), 16, *17*, 91, *91*
candlestick, 74, *75*; Lumiere (*Beauty and the
Beast*), *x*, *13*, 66, 74, *74*, 76, 77, *77–8*,
80; Meissonnier, Juste-Aurèle (design
attributed), *84–5*, *85*
CGI (computer-generated imagery), 1, 58, 96
Chambord, château de, 45
châteaux of the Loire Valley, 42, 45
China Shop, The, *4–5*, *4*, 26, *28–30*, *30–1*
Cinderella (1950), *3*, *5–7*, 19, 32; animation,
6–7, *8–9*; architecture, 7–8; background
for, *38–9*; Blair, Mary, *ii*, *5–7*, *6*, *7*,
34, *34–7*, *44*, 45; castle, 7, 8, 42, *43*,
43–5, 45; Cinderella fleeing the ball, *5*;
Cinderella looking into a mirror, *ii*, *35*;
Cinderella's father's country château, *36*;
Cinderella's stepsisters, *33*; Cinderella's
transformation, *6–7*, *7*, 40, *40–1*; dress,
33; early conceptual studies, *33*; King
at dinner, *6*; King and Queen, *33*; Lady
Tremaine and her daughters, *34*; Lady
Tremaine's bedroom, *38*; magic carriage,
7, *37*; Majolie, Bianca, 5–6, *5*; Rudiger,
Josephine 'Fini', *5–6*
Cinderella (Perrault, fairy tale), 3, 8, 10,
20, 32
Clock Store, The, *4–5*, 26, *27*, *31*
clocks: Boulle clocks, 70, *70*, 72; bracket
clock, *13*, 72; clock case, *90*, *91*;
Cogsworth (*Beauty and the Beast*), *12*,
13, *13*, 66, 70, *71*, 72, *73*, 80; mantel
clock, *13*, 27, 66, 72, *72*; Wallace
Collection, *13*, 70
Coats, Claude, 6
Crébillon, Claude Prosper Jolyot de: *Le
Sopha: conte moral*, 9, 92, *92*
Cupid (*L'Amour Falconet*), *10*, *11*, *11*

Davis, Marc, 7, *40–1*
Disney, Roy, 2
Disney, Walt, 1, 2, *3–4*, 7, 10, 11, 13, 16,
19, 20, 21, 24, 26, 32, 54, 60, 67; Europe

and, 2–3, 20–1
Disney Brothers Cartoon Studios, 2
'Disney Renaissance', 1, 54
Disney Studios: animation, 5, *11*; artists,
11, 16, *38–39*, 40, 62, 66; Ink & Paint
Department, 5, 7; 'Old Continent' and,
1; reference library, 3, 20, 22, 60; Story
Department, 5, 32
Disney theme parks, 7, 45
Ducrollay, Jean: snuffbox, *iv*, *15*, *15*
Dulac, Edmund, 6; *Cinderella's step-sister at
her toilette*, 2; *Sleeping Beauty*, 22
Duplessis, Jean-Claude Chambellan, the
Elder, 2, 15; clock case (design attributed),
90, *91*; 'ear' vase (design attributed), *15*,
88, *88*; elephant vase (design attributed),
18–19, 68, *69*; ship vase (design
attributed), *15*, *16*, *88*, *89*

Emperor's New Clothes, The (unproduced),
60, 61, *61*

Falconet, Étienne-Maurice, 4; *L'amour
Falconet*, *11*, *11*; *The Magic Lantern*, *3*,
4, 24, *25*; tower vases (design attributed),
47–8
Fantasia: dancing elephants, 68, *68*
Finn, Will, *11*, 66
Fragonard, Jean-Honoré: *The Swing*, *10–11*,
10, 54, *55*, 57, *58*
Frozen (2013), *ix*, *11*, 54, 59
Frozen 2 (2019), 1

Gillmore, Jean, 64, *64–5*
Goodge Street studio (London, UK), 1, 10,
54
Gouchon, Jacques: bracket clock, *13*, 72
Grant, Joe, *11*, 66, *80*

Hahn, Don, 54
Hall, Peter J., *10*; Beast, 62, *63*; Cogsworth,
12, 13, *70*, *71*; Lumiere, 74, *74*; Mrs
Potts, 79, *79*; The Swing music box, *vi*,
56, *56*, *57*
Hals, Frans: *The Laughing Cavalier*, *11*

Höchst Manufactory, 5; porcelain dancers, 4, 31
Hodgson, Mike, 8
Huquier, Gabriel, 93

Inspiring Walt Disney (exhibition), 2, 19
Italy, 16
Iwerks, Ub, 2–3, 67

Keane, Glen, 10, 58
Keene, Lisa, 11, 54, 58, 58

Lancret, Nicolas, 31
Lansbury, Angela, 82
Lima, Kevin, x, 77
Lorioux, Félix, 6; Cinderella and the Prince, 23
Louis XIV, King of France, 3, 43, 61, 62, 91
Lück, Johann Friedrich, 5; porcelain dancers, 4, 31
Ludwig II of Bavaria, 7, 42

Majolie, Bianca, 5–6, 5
McEntee, Brian, 11, 46, 46, 66, 80; Cogsworth, 13, 72, 73
Meissen Manufactory, 5, 26, 79
Meissonnier, Juste-Aurèle, 2, 15, 93; canapé, 93, 93; candlesticks (design attributed), 84–5, 85
Metropolitan Museum of Art, 2
Mickey Mouse, 2–3, 11, 66, 67
Morlay, François-René, 90
Mÿnuël, Louis, 71

Perrault, Charles, 23, 32
Pinocchio (1940), 3

Pompadour, Madame de, 11
porcelain, 4–5; eighteenth-century, 15, 26; porcelain dancers, 4, 27, 30–1, 30, 31; see also Höchst Manufactory; Meissen Manufactory; Sèvres Porcelain Manufactory
Pruiksma, David, 11, 66, 82

Quiller-Couch, Arthur: The Sleeping Beauty and Other Fairy Tales from the Old French, 2, 22

Ranieri, Nik, 11, 66
Reynard the Fox (unproduced) 61, 61
Richard, Claude, 90
Rigaud, Hyacinthe, 61, 62
Rococo, 2, 10–11, 16, 32; animation and, 1–2, 6, 66; decorative art, 13–16, 19, 24, 66, 91, 93; Rococo Revival, 2, 6
Rowley, George, 7, 40–1
Rudiger, Josephine 'Fini', 5–6

Saint-Aubin, Gabriel-Jacques de, 8; A Fête in the Colisée, 53, 53, 97
Sallé, Marie, 5, 31
Sanders, Chris, 12, 81
Schloss Neuschwanstein, 7, 42
Sèvres Porcelain Manufactory, 4, 5, 15; L'amour Falconet, 11, 11; 'ear' vase, 88; elephant vase, 18–19, 69; The Magic Lantern, 3, 4, 25; ship vase, 16, 88, 89; tower vases, 8, 46, 47–8, 48
Shaw, Mel, 10, 51, 57, 57, 62, 62
Silly Symphony series, 4, 11, 26, 60
Sleeping Beauty (1959, fairy tale), 3, 20

Snow White and the Seven Dwarfs (1937), 1, 3, 32
sofa: Beauty and the Beast, 9, 10, 94, 94–5; Crébillon, Claude Prosper Jolyot de: Le Sopha: conte moral, 9, 92, 92; Meissonnier, Juste-Aurèle: canapé, 93, 93; Tilliard, Jean-Baptiste I/II, 9
Strawitz, Kyle, 58
Swing, The: Beauty and the Beast, 54, 56, 57, 57; Fragonard, Jean-Honoré: The Swing, 10–11, 10, 54, 55, 57, 58; Frozen, ix, 11, 54, 59; The 'Swing' music box, vi, 56, 56, 57; Tangled, 54, 58–9, 58

Tangled (2010), 11; The Swing, 54, 58–9, 58
Technicolor, 5
Thru the Mirror (1936), 67, 67
Tilliard, Jean-Baptiste I/II, 9

Van Risenburgh, Bernard I: writing table, 14–15, 14, 87
Versailles, Palace of, 3, 7–8, 42, 43
Viger, François, 90
Villeneuve, Gabrielle-Suzanne Barbot de, 9–10, 54, 92
Vincennes Porcelain Manufactory, 15, 88; see also Sèvres Porcelain Manufactory

Wallace Collection, 1, 2, 10, 11, 13, 71
Walpole, Horace, 7
Walt Disney Animation Research Library, The, 62
Walt Disney Company, The, 2
Wickersham, Bob, 67

Published on the occasion of the exhibition *Inspiring Walt Disney: The Animation of French Decorative Arts*, The Wallace Collection, London, 6 April–16 October 2022; The Metropolitan Museum of Art, New York 6 December 2021–6 March 2022; and the Huntington Library, Art Museum, And Botanical Gardens, San Marino, 2022.

The exhibition is made possible thanks to the generosity of the following supporters:

Jake and Hélène Marie Shafran
Adrian Sassoon
Michael and Angela Cronk
The Rothschild Foundation
Michele Beiny Harkins
The Tavolozza Foundation
Marilyn and Lawrence Friedland
Kate de Rothschild Agius and Marcus Agius CBE

Catalogue supporter: The Elizabeth Cayzer Charitable Trust

The exhibition was organised by The Metropolitan Museum of Art and The Wallace Collection.

Philip Wilson Publishers
Bloomsbury Publishing Plc
50 Bedford Square, London, WC1B 3DP, UK
29 Earlsfort Terrace, Dublin 2, Ireland

Bloomsbury, **Philip Wilson Publishers** and the **Philip Wilson** logo are trademarks of Bloomsbury Publishing Plc

A catalogue record for this book is available from the British Library

Library of Congress Cataloguing-in-Publication data has been applied for

ISBN: 978 1 78130 118 0

10 9 8 7 6 5 4 3 2 1

Designed and typeset by Ocky Murray
Cover design by Ocky Murray and Patrick White (Designer, Walt Disney Animation Studios)
Printed and bound in Italy by Graphicom

To find out more about our authors and books visit www.bloomsbury.com and sign up for our newsletters